如果　會作夢
島嶼

WHEN ISLANDS DREAM

馬祖作夢計畫　Matsu Dreaming Project

Contents

of

When

Islands

Dream

目

次

Serendipity: Matsu Islands, Taiwan & Me

因緣際會，在馬祖作夢

謝宇婷
Hsieh Yu-Ting

《如果島嶼會作夢》策展人
Curator of *When Islands Dream*

直到1949年，「馬祖」的概念才首次確立。在國共內戰之前，馬祖列島是中國東南沿海漁民的季節性休息站，列島上的居民可以清楚地看到對岸福建的地形輪廓，而「臺灣」是他們幾乎不認識、也沒有任何關係的島嶼。但突然間，1949年國民黨軍隊抵達馬祖，馬祖成為中華民國的前線，將大砲瞄準對岸，一個他們曾稱為「家」的地方。可以說馬祖「因緣際會」地成為「臺澎金馬共同體」的一員，而我也是在「因緣際會」下，從2020年開始踏上從臺灣本島往返馬祖的旅程。

一無所知，大膽作夢

一直以來，馬祖對我來說只是遙遠的地理名詞。我從未結識任何與馬祖有關的人，也從沒想過活在戰地前緣是什麼感覺。然而，2018年我在國立臺北藝術大學就讀博物館研究所時，修習吳瑪悧老師的課程「創造思考——藝術與公共領域」，課堂中，馬祖作家劉宏文和文化工作者廖億美分享了他們在島上的生活經歷和觀察：永無休止的戰爭塑造了島嶼的景觀、建設、文化和社會網絡，而在島嶼迅速轉變為旅遊景點的過程中，歷史創傷其實仍未真正癒合。恰好我的碩士論文探討冷戰亞洲的困難歷史，一種「我應該知道但我什麼都不知道」的感覺衝擊著我。

偶然地，我發現馬祖北竿獨特的「祈夢」儀式：每年農曆正月29日，人們來到廟裡，帶著他們對未來的疑問入睡、作夢，夢裡閃現的畫面，就是神祇的回覆。當提問人難以入夢時，可委由較為靈敏的「代夢人」代為作夢提問，協助接收神明諭旨。「作夢」在此成為一種提問的方式，提問者讓渡主體，邀請代夢人參與，透過更敏感、直覺的方式感應。我立即將這一概念與藝術家的角色連繫起來，對我而言，他們正是跳脫常軌、大膽替社會作夢的代夢人。如果藝術家扮演「代夢人」的角色為馬祖作夢，會發生什麼事？

詩人白靈曾形容外島總是為本島服務，「看似地處邊境，卻始終作著別人的夢，無法選擇自己的未來」。藉由以馬祖列島為主體出發的作品與展覽，我嘗試翻轉這樣的視野，不僅重探馬祖的歷史，也試圖接近列島的精神狀態。馬祖列島作為戰地前線，經歷過比臺灣本島更漫長嚴苛的戒嚴，無論是交通、貨幣、捕魚出航時間、夜裡不得有燈火等，生活各方面都受到限制。長期作為前線的各種犧牲，也讓臺灣本土意識興起後的「金馬割棄論」難以被島民接受。（這可視為一種「離島犧牲、本島享受」的犧牲體系。此概念出自高橋哲哉《犧牲的體系：福島・沖繩》一書，馬祖文學研究者劉亦以此框架討論馬祖與臺灣本島的關係。）然而這些文獻之外的常民經驗與幽微的情緒，是博物館、「保家衛國」的戰地歷史遺跡展示中較少觸及的。夢有沒有可能是一種通道，讓我們能稍微接近、探問如地下坑道般錯綜潛藏的情緒與精神狀態？

夢與現實的距離

很幸運地，上述構想讓我獲得國家文化藝術基金會策展人培力的補助。審查會議上，策展人徐文瑞問我「你是馬祖人嗎？」我搖頭，「那你去過馬祖幾次？」彼時還未去過馬祖的我，據實以告。他的提問，彷彿預知了我後來在田野調查與整個展覽製作過程中，對於自己與團隊「外來者」身份界定的反覆詰問。

作為外來者，我與參展藝術家未曾經歷戰爭帶來的禁錮與創傷，因此我們只能謙卑地嘗試接近、想像與理解。經驗的空缺也提供了新鮮敏銳的洞察尺度，當我們指出當地人習以為常事物的特殊之時，也讓居民重新審視他們再熟悉不過的日常。更甚者，戰地遺跡是過去居民不得進入、接近的場址，即便戰爭大幅改變、壓縮了他們的自由。他們是居住在島上的社群，然而在掌權者眼中，他們是需要被控管監視的「他者」。直到1992年解嚴後，戰地才逐步開放，無論是外地人或馬祖人，對於軍事地景的認識，至今都還存在著巨大的空白。因此，透過重新想像演繹馬祖地景，藝術得以賦予地方多元的感知可能，外地與本地的交互詮釋、對話，也賦予島嶼更多重的觀點。

另一個策展過程的核心問題，則是「代夢」的本質。最初我的發想源於創傷理論——難以言說的創傷往往透過夢境浮現，如同諾貝爾文學獎得主埃利亞斯・卡內蒂（Elias Canetti）所言，「所有你遺忘的事物都會在夢中呼喊著求救。」然而實際體驗過祈夢儀式後，我發現祈夢者的提問大多反映個人朝向未來的世俗願望，而非面向過往的回憶。

因此，我重新檢視這次展覽中的「代夢」概念。首先，藝術家代理作夢的對象不限於島民，

而是將馬祖列島視為一個整體，包含島上的地景與事物，因而得以透過更豐富的視角出發。這也是展名《如果島嶼會作夢》的命名起點。其次，代夢不等同於代言，代言者提供具體精確的定義，代夢者則僅能傳遞夢中閃現的畫面，如同藝術家的作品中那些模糊、混沌的影像與聲音片段，或是僅能透過觸覺感知的符號，都保留了解讀的空間。

除此之外，執行過程的挑戰，還包括我作為美術館館員與獨立策展人身份之間的拉扯。計畫初始時我於臺中的國立臺灣美術館任職，而後又轉往高雄市立美術館。兩年來只能利用連假空檔，往返高雄與馬祖兩地。加上經費限制，駐島時間為時甚短，也考驗著我與藝術家如何在最壓縮的時間內摸索出可發展的創作方向，並且高度仰賴當地朋友提供的資訊與情報。作為我的首次策展，以及首次委託製作，也讓非藝術背景的我，不斷在過程中釐清策展人的角色，以及委託製作中需要提供藝術家的指引與彈性。

島與島之間的夢境通道

回到展覽現場，進入展間前的走廊是展覽的楔子，舞踏藝術家許生翰的錄像作品〈島迴〉。夢遊般徘徊於馬祖南竿各處的兩具身體，彼此繞行交替。島嶼的身體感是不斷地環繞、重複，沒有出口，過去難以言說，未來也尚未清晰。接著走進第一個展間，是王煜松於東莒東犬燈塔駐村一個月後製作的藍曬作品〈在燈塔的日子〉，異地對照的生活如同夢境，不斷地與臺灣類比，如同現實的抽樣。

前述兩位藝術家以個人的感知來經歷島嶼，另外三位創作者則透過與當地居民合作，試圖建構屬於島嶼的夢境。黃祥昀設計了〈記憶刺點：攝影與製圖工作坊〉，帶領參與者以「心理地圖」的方式重新理解馬祖，再透過藝術家書的形式，讓展場觀眾以觸摸、翻閱的形式體驗工作坊。澎葉生（Yannick Dauby）則在錄像作品〈在馬祖，她一無所聞。她聽聞一切。〉中交錯居民訪談、島嶼聲音、影像以及鬼魂般的「她」的旁白。島嶼時而安然自在，時而戒備緊張，藝術家拼接島嶼的日常，以及日常之中看似不存在，卻不斷進逼的威脅。最後是艾瑪·杜松（Emma Dusong）的〈面向汝〉，她收集島上居民對於過去戰地政務時期的提問，提煉譜寫成曲，由馬祖人與藝術家共同以馬祖話演唱。

從實際以身體、時間與聲音感知島嶼地景（許生翰、王煜松、澎葉生），而後透過心理地圖解構島嶼圖像（黃祥昀），最後閉上眼，聆聽島嶼的聲音與島民的歌唱（艾瑪·杜松），觀眾一步步跟著藝術家由外而內接近島嶼的形象，也由淺入深地進入這個由本島、外島、本國、外國視野共築的馬祖夢境。五件作品都帶著夢的漂移與迷濛，沒有哪件作品明確告知

歷史或事件，而是化身為島嶼潛藏的精神意識，包圍著觀眾。

因此，為了替作品背景補充脈絡，展間還特別規劃了一張閱讀小桌，展出馬祖相關的文本，包含馬祖作家劉宏文的《鄉音馬祖》、馬祖詩人劉梅玉的詩集《耶加雪菲的據點》、白色恐怖散文選《失落的故鄉》以及祈夢儀式的相關資料。小桌上也設置了「代夢卡」，邀請觀眾提出他們想要詢問的問題以及期望的代夢人選，從詩人、藝術家到政治人物皆可。最後收集了 400 多張代夢卡，其中有關「臺灣的未來」、「馬祖的觀點」等問題為數不少，顯現出展覽激發了觀眾進一步思考島嶼的定位與命運。

雖然展覽位於臺北，馬祖觀眾較不易抵達，不免讓人遺憾，然而在臺北市中心的台北當代藝術館展出，某種程度上也翻轉了離島的邊陲位置，讓許多臺北、臺灣本島的觀眾不再僅以旅遊景點去想像馬祖，而是真正思考「臺澎金馬共同體」框架下臺灣群島的關係。在東莒大浦聚落工作的臺灣朋友陳泳翰曾這麼說：「每個臺灣人都聽過馬祖，但卻從未真正理解過馬祖人。」但願展覽能夠達到哪怕一丁點改變，讓觀眾在藝術作品創造出的夢境空間中，不受到政治立場或意識形態左右地去接近馬祖，開啟更多對話與交流的可能。

如果沒有馬祖朋友的支持，我不可能完成這個計劃。緊接《如果島嶼會作夢》後於 2022 年春天開幕的首屆「馬祖國際藝術島」，延續著對馬祖列島的藝術探索和改造。可以肯定地說，馬祖已經開始了新的動員階段，然而這次不是軍隊與戰備建設，而是藝術與文化的重塑。未來十年，馬祖列島如何持續發展和實踐自己的夢，值得我們關注。

（本文改寫自作者於 Taiwan Insight 網站上發表的 Serendipity: Matsu Islands, Taiwan & Me 一文，為 Matsu Today 專題一部分，刊登於 2022 年 3 月 29 日。）

It was not until 1949 that the concept of "Matsu" first emerged. Before the Chinese Civil War, this group of islands was mostly a seasonal resting stops of fishermen from the south-eastern shores of China. For residents on the archipelago, they can see the outline of Fujian across the shore clearly, whereas "Taiwan" was an island they hardly knew nor had any relationship with. But all of a sudden, Kuomintang armies arrived at Matsu islands in 1949 and in no time, Matsu became the frontline of Republic of China, aiming cannons at the opposite bank, a place they used to call "home." Serendipity, to put it romantically, is how the "Taiwan-Penghu-Kinmen-Matsu Community" came to be of today. And I tend to think that it is also serendipity that guided me, a descendant of Minnan and Hakka from Taoyuan City, to embark on this journey to-and-from Matsu since 2020.

Knowing Little Yet Dreaming Big

Albeit I've learned about Matsu in school, the archipelago remained a distant geographical term to me. Not only had I never met anyone who is related to Matsu, it never occurred to me how it was like to live so far away from Taiwan island but so close to mainland China, or be at the brink of war. Matsu first entered my life when I took a selective course "Creative Thinking: Art and Public Realms" by Professor Wu Ma-Li in 2018 while pursuing my master's degree of museum studies in Taipei National University of the Arts. The course invited Matsu writer Liu Hung-Wen and cultural worker Liao Yi-Mei to share their life experiences and observations of the islands. Liu shared how the never-ending war has shaped the landscape, construction, culture and social networks of the islands, while Liao introduced how the historical trauma remained unhealed as the islands quickly transforming into tourism spots. The sharing hit me that "I should have known yet I knew nothing" as I have been investigating the post-cold war difficult histories across Asia for my master thesis.

Later on, I came across a unique religious ceremony, the Dreaming Ceremony, that takes place at Beigan, Matsu. On the 29th of the first lunar month, people go to the temple to fall asleep and dream with their questions about the future. The images that appear in their dreams are the replies of the gods. Sometimes, when the questioner has difficulty falling asleep, a more sensitive "dreamer" may be appointed to ask a dream on their behalf to help receive the gods' instructions. I immediately related this concept to the role of artists, who function as an integral dreamer to dream wildly and creatively for the society. What would happen if artists play the role of the dreamer and to dream in place of Matsu?

The poet Bai Ling once described that the offshore islands as always serving the main island, "seemingly on the border, but always dreaming someone else's dream, unable to choose their own future." By using Matsu as an anchor point for reflection, I attempt to revisit not only the past but also the mental state of the islands. With a longer-lasting and harsher martial law than the main island of Taiwan, Matsu endured restrictions on transportation, currency, fishing sailing hours, and even lighting at night. These various sacrifices made at the front line for a long time also made it difficult for the stance of "Kinmen-Matsu Abandonment" to be accepted by Matsu islanders after the rise of Taiwanization. Yet the museums and relics that showcase the history of the "proudly defending the country" rarely touch upon such subtle emotions and ordinary experiences. Is it possible that dreams can be a gateway that allows us to get a little closer and explore the emotions and spiritual states that are hidden like underground tunnels?

The Distance Between Dream and Reality

Luckily, the above-mentioned concept won me the Curator's Incubator Program from the National Culture and Arts Foundation. During the interview, one of the committee member, Manray Hsu, asked me, "Are you from Matsu?" "No." "Then how many times have you been to Matsu?" "None." I replied honestly. His questions hint the upcoming inquires the artists and I face during our fieldworks and the whole process of curating.

As outsiders, the artists and I didn't experience the confinement and trauma of war. As a result, we can only humbly approach, imagine and understand. The vacancy of experiences also provides a fresh and keen insight. As we point out the peculiarities of what the locals have taken for granted, we also allow the residents to re-examine their all-too-familiar routines. Even though the war drastically changed and compressed their freedom, they were the "others" that needed to be controlled and monitored in the eyes of those in power, even when they were the community that lived on the island. It was not until after the withdrawal of the army that the military zone gradually opened up, resulting in a huge gap in the knowledge of the military landscape for both outsiders and the Matsu natives. Therefore, by reimagining and reinterpreting the Matsu landscape, art can give the place multiple perceptual possibilities, and the interactive interpretation and dialogue between foreigners and locals can give the island more multiple perspectives.

Another core inquiry in the curatorial process was the nature of "dreamer." Initially, my idea originated from trauma theory, where unspeakable trauma often emerges through dreams, as Nobel Laureate in Literature Elias Canetti said, "all the things one has forgotten scream for help in dreams." However, after participating in the Dreaming Ceremony, I found that the questions asked by the dreamers mostly reflected the individual's secular wishes toward the future, rather than memories of the past.

Therefore, I re-examined the concept of "dreamer" in the exhibition. First, the artists not only dream on behalf of the islanders, but the Matsu Islands as a whole, encompassing the landscape and creatures on the island, which allows for a richer perspective. This was also the starting point for the title of the exhibition, *When Islands Dream*. Secondly, dreaming on behalf of others is not the same as speaking for others. While a spokesperson provides a specific and precise definition, the dreamer can only convey the flashing images in the dreams, akin to the artworks. Those blurred, unclear images and sound fragments, or symbols that can only be perceived through the sense of touch, all retain the space for interpretation.

In addition, the challenges of the curatorial process included balancing my full-time job in an art museum and working as an independent curator. I worked at the National Taiwan Museum of Fine Arts in Taichung at the beginning of the project, and later moved on to the Kaohsiung Museum of Fine Arts. For two years, I could only travel between Kaohsiung and Matsu during long holidays. Along with the financial constraints, the minimal time we can spend on the islands tested how the artists and I could develop a creative direction in the most compressed time frame, and how closely we have to collaborate with local friends. This was also my first curatorial project and first time commissioning artworks. Being inexperienced and lacking training in the art field, I have to constantly adjust my role as a curator and how much guidance and flexibility I should provide during the commissioning process.

A Dreamy Passage Between Islands

To align with the concept of "dreaming" , the five artists I invited all share similarities of dreaminess. For instance, in the work *Winding Islands, Revolving Dreams*, Butoh dancer Sean Trudi Hsu and another dancer wander on Nangan island, seemingly dream walking, dragging, with a sense of depression looming over the island. Yannick Dauby's *She heard nothing in Matsu. She heard everything* also takes the audience to wander on the paths of Matsu through the guide of sounds. A distant "she" overlooks the islands, travels through daily mundane scenes as well as nerve wrecking threats from mainland China. Wang Yu-Song's *Days in the Lighthouse*, on the contrary, stays mainly at the Dongju Lighthouse, reimagining the life of lighthouse keeper. Huang Hsiang-Yun's *Memory Punctum: Photography & Cartography Workshop* and Emma Dusong's *Facing You (Měing-hyong nỹ)* call for deeper collaboration with Matsu residents and the artists. Huang invited workshop participants to transform their living experience and senses of walking in a tunnel blindfolded into their personal mental map of Matsu. Dusong composes music for three inhabitants of the Matsu Islands in their dialect, singing out their fears and questions.

The five artists to Matsu responded to the exhibition theme with their unique approaches, forming different dreamscapes that echo one another. Whether they perceived the island in a personal and physical way, or collect the memories and perspectives of local residents, the artists tried to treat the island as the main subject, while their personal perspectives still intersect with the residents and the place. This very nature is where the unique value of "dreaming for others" lies — we are allowed to withdraw from ourselves to immerse in the state of the other, and then to return to ourselves to convey and interpret the dreams of others. It is also intriguing that it seems to be easier for foreign artists to dream in place

of Matsu compared to Taiwanese artists, who often times doubt if they were eligible to do works about Matsu. Yet this cautious mindset is also valuable as too often the islands have been represented wrongly or their opinions ignored.

In order to provide context to the works, a reading table was set up in the exhibition to display Matsu-related texts, including Matsu writer Liu Hong-Wen's *Voices of Matsu*, Matsu poet Liu Mei-Yu's poetry collection *The Fort of Yirgacheffe*, the White Terror essay anthology *The Lost Homeland*, and materials related to the Dreaming Ceremony. There were also "Dream for You Cards" on the small table, inviting the audience to ask questions they would like to be asked and who they would like to have as the dreamer, ranging from poets, artists to political figures. More than 400 dream cards were collected, including many on "Taiwan's future" and "Matsu's point of view," showing that the exhibition stimulated the audience to further consider the island's position and destiny.

Despite that the exhibition was less accessible to Matsu audience as it was located in Taipei, the fact that *When Islands Dream* exhibiting in the Museum of Contemporary Arts Taipei in the center of Taipei City has, to a certain extent, reversed the long-standing unequal relationship between the nation's capital and its outlying islands. It also allowed many visitors from Taipei and Taiwan to view Matsu not just as a tourist destination and to truly reconsider the relationship between the Taiwan islands within the framework of the "Taiwan-Penghu-Kinmen-Matsu Community." Chen Young-Han, a Taiwanese friend who works in the Dongju Dapu Village, once said, "every Taiwanese has heard of Matsu, but has never really understood the Matsu people." I hope the exhibition can bring about even a small change, inviting the audience to approach Matsu in the dreamlike space created by the artworks, without presumptions of political stances or ideologies, and opening up more possibilities for future dialogue and communication.

Without the support of Matsu people, it would be impossible to make my "dream project" come true. With the inaugural Matsu Biennale that opened in Spring 2022 continuing this artistic exploration and transformation of the Matsu islands, one can be sure to say that Matsu has begun a new stage of mobilization. However, this time it is not the army and military infrastructure but the soft power of arts and culture. It will be worth our attention to observe how the islands develop and realize their dreams over the next decade.

(The article is expanded from the same titled article first published on *Taiwan Insight* Website on Mar 29, 2022.)

Misty Islands, Dreamy Reception On When Islands Dream

迷霧島嶼・夢體收音：
論《如果島嶼會作夢》

龔卓軍
Gong Jow-Jiun

臺南藝術大學藝術創作理論研究所博士班 副教授兼所長
Associate Professor and Director of PhD Program, Institute of Art Creation Theory, Tainan National University of the Arts

用起霧的心境來創作，表現明白與未明白之間的話語與圖像，那些確實存在的模糊，易被誤讀的生活表象，總是在清澈的那一刻，才會懂得——看不清也是一種看清。

<div align="right">——劉梅玉《寫在霧裡》自序</div>

出生在北方之北的邊境東引，長居南竿，長年生活在瀰漫、圍繞著島嶼白茫茫迷霧裡的詩人劉梅玉曾說：「用起霧的心境來創作，表現明白與未明白之間的話語與圖像，那些確實存在的模糊，易被誤讀的生活表象，總是在清澈的那一刻，才會懂得——看不清也是一種看清。」2021年底，我在台北當代藝術館（MoCA Taipei）看了《如果島嶼會作夢》這個展，如同進入了一團迷霧中，也好似走進了一場夢境，周身圍繞著陌生的語音，窸窸窣窣的陳述，沒有來由地吟唱，以及三位看似在作夢中的人影。其中一位作夢者身影，就是詩人劉梅玉。

這個展覽最大的特色，就是它在展場中的佈置，包括視效影像、聲音影像與裝置，並沒有將我們的感官機能所收到的訊息，串聯到某種完整的「動作－影像」中，去說一個完整的故事。這些感知並不延伸為完整敘事，我們找不到一幕幕接續完整的馬祖故事，而是在「回憶－影像」與「夢幻－影像」之間徘徊，讓真實與想像、物理與心智、客觀與主觀、描繪與敘事、現實與潛在之間，就像德勒茲（Gilles Deleuze）在《電影 II：時間－影像》一書中討論的羅塞里尼（Roberto Rossellini）電影《火山邊緣之戀》（Stromboli，1950），在火山島史憧波歷（Stromboli）上，登陸、捕魚、大地震動、火山爆發、異鄉人登高、精神崩潰，這一連串的場景與聲響「不再存在感官機能影像以及它的延伸，而是一邊純聲光影像與另一邊來自時間與思維的影像之間，更為複雜的循環關係。這些鏡頭理所當然地共存著，一起組成該島的靈魂與身體。」（頁436）對於《如果島嶼會作夢》這個展覽的感知，就如同進入了他者的夢境，許多原本在政宣影片、愛情片、警匪片、科幻片裡的規整敘事影

音，在這裡被打散。仔細觀看聆聽個別作品，觀眾會更進一步被引導入益發碎形化的影音效果中；然而，你卻確知這一切都在指向一組島嶼，指向馬祖諸島，彷彿發夢的是這幾座島嶼上大大小小萬事萬物的身世。出了展場，夢境結束，卻什麼細節也記不得，只知道這些島嶼勢必經歷了異樣的時間與思維，你碰觸到的是列島發夢時的靈魂與身體，一切都看不清、聽不明白，如夢似幻。

直到兩個月後，2022年2月，我實際登島參訪，才有乍然看清聽清的體悟。登島的第一天，恰是農曆正月13日，我坐船赴北竿參與「坂里十三暝」的擺暝祭典。「擺暝」傳承了中國大陸福建閩東區域（福州、長樂、連江等地）在元宵時節，村境廟社集結眾人、祭祀神明的習俗。每年擺暝，坂里村都要請白馬尊王的香爐到廟社，十三暝整日有完整的祭典過程，從早上的擺筵、擺燭，下午的神乩拜年，傍晚的請香迎神、遶境燒馬糧，一直到深夜還有送喜、添花、辦喜酒，以及半夜唱唸請神簿等儀式。坂里大宅，熱鬧非凡，各路請香迎神隊伍，與眾人一齊前往中澳白馬尊王廟迎神起駕，共同遶境。白馬尊王以收瘟、祈雨之神聞名，這一天傍晚，果然在低溫中下起了雨，雖然因疫情考量而縮小規模，但熱鬧的氣氛依然不減。在這種濃厚的民間宗教氣氛中，同樣在馬祖北竿，芹壁村的龍角峰五靈宮廟，每年到了農曆正月29日，相傳何仙翁會到此讓信眾祈求夢境解惑，這就是所謂的「祈夢」。由於每年只有一次，這一天，許多馬祖鄉親會爭相來求夢，人手一件棉被、枕頭，排隊到廟裡睡覺祈夢。更有趣的是，如果祈夢者睡不著，過於清醒，還可以請別人幫忙作夢。

祈夢者與代夢者，感應神明啟示的影像與聲音，就成了《如果島嶼會作夢》辯證的出發點。馬祖在第二次世界大戰後歷經了冷戰結構下的國共對峙「戰地政務之夢」，這個長眠難醒的夢境，讓馬祖成為台灣本島的「犧牲體系」——犧牲居民與地景自由無拘束的狀態，以等待戰爭、準備戰爭來取代島嶼的日常生活，交通、貨幣、捕魚出航時間、夜間燈火管制都在戰備犧牲之列。一直到1992年解除戒嚴，島嶼的聲音才漸次浮現。曾經擔任過議員與文化局長的「刺鳥咖啡書店」主人曹以雄曾經說過：「對我來說，台灣才是我的離島」。台灣／馬祖主奴之辯證，於此升起。30年來，何謂馬祖在地的聲音，成為解除戰地政務後「馬祖之夢」的嶄新命題。

《如果島嶼會作夢》運用了「代夢人」這個常民實際信仰生活中類似卜測命運靈媒的角色，以五位非馬祖人藝術家的夢體 媒介，在馬祖感受、接收聲音與影像，協力卜測解鎖這組列島的夢境。若我們用約翰威利（John Wylie）在《地景》（Landscape）一書第五章〈地景現象學〉的概念來看待王煜松、許生翰、黃祥昀、澎葉生（Yannick Dauby）、艾瑪・杜松（Emma Dusong）的作品，可以看到《如果島嶼會作夢》非常側重返回「身體主體」的策展角度。這個展覽對於相互糾纏的視覺、聲覺、體現，給予了豐富的交織線索，突顯的是

藝術家投身於馬祖列島的經驗，而不是拉開距離的反思，讓這些展示的影音既存在馬祖世界的草叢、海岸、坑道、碉堡、射口、閩東語境之中，也從屬於這個外地人所不熟悉的世界，他們浸潤其間，同時進一步「創生空間」，運用不同的夢體媒介與周遭的馬祖世界直接對話與調適。

首先是許生翰的〈島迴〉。藝術家在馬祖地景中，創造了兩具夢遊的身體。或許跟疫情高漲，藝術家駐地時的侷促條件有關，許生翰自訴他「夢遊似地環繞馬祖的地景，以非人之姿進行遊蕩。走過坑道、老房、海石與道路，海浪繞著馬祖周圍的尖刺，再次將夢遊者推回坑道當中，周而復始。」影像中白色身體的抑鬱感，不禁讓我們想到1960～1970年代攝影家張照堂作品中的抑鬱青年身體。我們當然可以說，缺乏實際生活於島嶼的經驗，甚至是面對物資與時間條件匱乏下創作的壓力，或許是這種抑鬱感的來源之一。但是，不只一位藝術家告訴我，當他一再進出不同的據點坑道，在陰暗與光明的交錯中一無所獲地來回、面對空蕩的海域時，漸漸生出一種想要嘔吐的感覺。對於沒有當地生活經驗支撐的台灣人來說，去除了觀光目的之後，馬祖究竟意味著什麼？許生翰的夢遊身體演繹，不僅反映了過去在這些據點出沒的服役軍人身體，也像是日本舞踏者浸潤於惡地惡所時，沒有出路的扭曲身體樣態。這裡的惡所，改換為廢棄的軍事據點，非家鄉亦非異鄉，而是一團卡夫卡城堡式迷宮中的夢遊者，循行著沒有盡頭與沒有答案的黯黑通道，面對著沒有異動與沒有風景的海岸風景。

其次是王煜松的〈在燈塔的日子〉，這是一個留守的持守者身體、在燈塔中度日與發光的身體。對於馬祖來說，「等待」是最長的夢魘，「等待」也是被常態化的日常心境。等待戰爭的到來，等待運補的到來，等待壞天氣的結束，等待霧開雲散的視野。但反覆到來的沒有別的，還是那樣的無止境的「等待」。王煜松把「等待」的時間影像，轉化為主動選取視角的藍曬圖。他把自身身體轉擬為運動不歇的東莒燈塔，以燈塔守，以燈塔本身，以燈塔之光來象徵馬祖之夢。這件作品從王煜松前一件作品〈花蓮白燈塔〉的創作脈絡延伸而來，讓觀眾脫離了抑鬱的夢遊者身體，化身為雖然固著不動，實際上卻有重要指引作用的燈塔持守者身體。從燈塔內部的旋梯，到燈塔守出入的小門；從光的輪廓，到陸地小徑與海路指向的海面目標，〈在燈塔的日子〉強調一個在黑暗中堅持溫柔發光的發光體。如果這也是島嶼的夢境，它的畫面顯得如此的平靜，卻能讓我們想像燈塔在狂風暴雨中，用光束與風雨大霧搏鬥的時空力度。

然後是黃祥昀的〈記憶刺點：攝影與製圖工作坊〉，這是一個觸覺式身體，讓參與者可以去觸摸特屬於馬祖坑道中的粗礪石塊、炮室中消音用的尖刺構造、瓊麻類植物的尖刺邊緣，以此與地景張力和身體觸覺記憶對話。這個工作坊重視觸覺式的身體地景閱讀，這是一般

展覽幾乎完全忽略的項目，可見策展人在方法論上，對於身體與地景辯證對話，給予了很大程度的發展比重。藝術家帶領工作坊的參與者，回到對自己有「重要意義的地方蒐集石頭、以觸覺和身體體驗坑道的質感，藉此回憶在自己意識流中的馬祖地景，製作一份融合感受、回憶與想像的『心理地圖』。」在地景觸覺轉化為圖像的過程中，帶入對於這些細節刺點的閱讀式體驗，黃祥昀透過這樣的方法落實了「精神地理學」中地景尖刺感的採集，形成了觸覺的敘事。

澎葉生的〈在馬祖，她一無所聞。她聽聞一切。〉集中在聲景本身的剪輯與敘事，讓固定的馬祖影像如回憶也如夢境般流動起來，這是我從馬祖之行回台灣，再重看幾次這件作品後，感受到的聲景身體。因為錄音品質的貼近，不論是在坑道中，在蟬鳴聲中，在庄頭廣播，在海岸邊，在壕溝行走，在聽到抽沙聲，在聆聽閩東語，在一個一個接受訪問的島民的敘事中，我們突然得以沉靜下來，進入了一個非常低速的「日誌錄音帶」空間裡。這個「日誌錄音帶」播送的不再是無聊的政宣聲音，或說即令是過往的政宣聲音，也在這些前前後後的變異聲景與敘事中，變得如夢境般產生了遙遠迷人的懷舊感。然而，這個當代馬祖聲景的敘事，交纏著更多島民在過去、現在與未來之間的憂慮與不安。我們聽到的是幾種不同的心境，在這些回憶、對現在的不解、對未來的疑惑交錯間，各種不同的蟬鳴鳥囀反而變得異常清晰，經過地景與坑道時的悉悉窣窣聲反而變得異常有體感。聲音這個媒介，在一位不知名的女性幽魂帶領下，穿越馬祖不同的時空記憶與萬物地景，形成了一個複音重奏的聲景世界，馬祖本身多樣歷史的身世，得到了純粹影音效應的碎形鋪陳，而不再統一停留在某個意識型態的大敘事框架之中。馬祖之夢，於是在地景間以微物並綴的方式流動不居。

最後是艾瑪‧杜松的〈面向汝（Měing-hyong nў）〉，這組夢境影音詩作，讓觀眾面對影音並置的作夢身體。藝術家嘗試以台灣人非常陌生的馬祖閩東話為媒介，為三位島民譜曲。「面向汝／當我們睡覺時／我們作夢／當我們作夢時／我們質疑／當我們質疑時／我們站起／當我們站起／我們有動力／我們是」。在作品的影音情境中，三位島民在影像中各自提問，站立著，但投影在床墊上，讓他們彷彿漂浮在床墊上，像巨石一樣升起，恍若教堂中的三聯畫。當其中一人清唱時，另外兩個人復現，暗示歌聲的召喚力量，創造集體宣訴的能量。有趣的是，這些馬祖居民在睡覺時，因為時差關係，藝術家卻是在法國的地中海岸歌唱，與馬祖的海相互呼應。艾瑪‧杜松完全沒有迴避她作為一個外國人的身份，一個來自受疫情阻隔於遠方存在的身份。通常祈夢儀式都會把重點放在視覺性的閃現畫面，藝術家在此把焦點轉向在地的聲音與歌吟，這些帶有質疑提問的詩歌之聲，彷彿與馬祖的蟬鳴、鳥囀、海岸拍浪聲相互呼應。就像〈在馬祖，她一無所聞。她聽聞一切。〉結尾所暗示的那樣，真正記錄馬祖身世的，或許是這些鳥鳴聲，但是〈面向汝（Měing-hyong nў）〉，

或者說整個《如果島嶼會作夢》展覽更進一步，深入夢境中的心境，將馬祖的島嶼身世轉化為一個問句，一些質疑，在夢境的最深沉處，是無可比擬的影音詩景，讓我們得以面對我們的生存恐懼。

（本文首次出版於《藝術家》雜誌第562期，2022年3月號）

I create with the state of mind of the fog, and I express the words and images between the understood and the ununderstood, as the blurred and misinterpreted appearances of life do exist. It is always at the moment of clarity that one understands that - not being able to see is also a kind of seeing clearly.

Preface of *Written in the Fog* by Liu Mei-Yu

The poet Liu Mei-Yu, who was born in the northern border of Dongyin and has been living in Nangan for years in the white fog that surrounds the island, once said, "I create with the state of mind of the fog, and I express the words and images between the understood and the ununderstood, as the blurred and misinterpreted appearances of life do exist. It is always at the moment of clarity that one understands that - not being able to see is also a kind of seeing clearly." At the end of 2021, I saw the exhibition *When Islands Dream* at the Museum of Contemporary Art Taipei, and it was like entering a fog and a dream, surrounded by unfamiliar voices, small and long-winded statements, unexplained chanting and three seemingly dreaming figures. One of the dreaming figures is the poet Liu Mei-Yu.

The most distinctive feature of this exhibition is that its arrangement in the exhibition space, including visual effects, sound images and installations, does not link the information received by our senses into a complete "motion-image" relation to tell a complete story. In other words, they do not extend to the perception of a complete narrative where audience can read in a sequence scene by scene. Instead, we are torn between "memory-image" and "dream-image," between reality and imagination, physicality and mentality, objectivity and subjectivity, depiction and narrative, actuality and potentiality. Such experience resembles how Deleuze discusses the volcanic island Stromboli in Rossellini's *Stromboli, terra di Dio* in his book *Cinema II: The Time-Image* — in the series of scenes and sounds of landing, fishing, earthquakes, volcanic eruptions, alien ascents, and spiritual collapses, "there are no longer sensory-motor images with

their extensions, but much more complex circular links between pure optical and sound images on the one hand, and on the other hand images from time and thought, on planes which all coexist by right, constituting the soul and body of the island" (Deleuze 47). To perceive the exhibition *When Islands Dream* is to enter a dream world of others where many of the regular narrative videos of political propaganda films, romance films, police procedurals, and science fiction films are broken apart. Thus, when the audience attentively watch and listen to each individual work, they would be led to even more fractalized audio-visual effects. Yet, even so, the audience are still firmly aware of the fact that everything just refers to the same islands, the Matsu Islands. The dream is almost about the life of everything on the islands, large and small. When you leave the exhibition, the dream ends, but you cannot remember any details, except that the islands must have experienced a different time and thought, and what you have touched is the soul and body of the islands when they dream. Everything is unreadable and unintelligible, just like a dream.

It was not until two months later, in February 2022, when I actually visited the islands, that the perception of seeing and hearing clearly finally dawned on me. The first day I visited the islands was the 13th of January, and I took a boat to Beigan Island to participate in the "Ban-li 13th Night" of the Baiming Festival." Inherited from a tradition of the east of Fujian Province, China (including places like Fuzhou, Changle, and Lienchiang), the village temple community gathers to worship the gods during the Baiming Festival. Every year, Banli Village invites the incense burner for the King of White Horse to the temple community. A full-fledged ritual takes place all through the day of the 13th Night, from the setting of the feast and candles in the morning, the worship of the gods in the afternoon, the invocation of incense to welcome the gods in the evening, the burning of horse feed in the parade, and the late-night rituals such as sending happiness, adding flowers, hosting a wedding reception, and singing the invocation book at midnight. At Banli Mansion, there is a great deal of activities as the various incense-offering teams go to the White Horse Temple in Zhong'aokou to welcome the gods and hold the procession together with the crowd. The King of White Horses is famous for ending the plague and sending rain. And that day, it did rain in the low temperature in the evening. Although the scale of the event was reduced due to the pandemic, the bustling atmosphere remained unabated. In the midst of this strong folk religious atmosphere, it is said that on the 29th of the first month of the lunar calendar every year at the Longjiaofeng Wulinggong Temple in the village of Qinbi, also in Matsu Beigan, He Xian Weng will come to let people pray for a dream to solve their problems. Since it only takes place once a year, many Matsu villagers come to pray for a dream on this day and

line up at the temple with a quilt and pillow. What's more interesting is that if the dream supplicant is unable to sleep and is too wide awake, he or she can ask others to help him or her to receive a dream.

The prayers and dreamers, and the images and voices revealed by the deities became the starting point of a dialectic in *When Islands Dream*. After World War II, Matsu experienced the "dream as the War Zone Administration Committee" under the Cold War structure of the confrontation between the Communist Party and Taiwan. This long-lasting dream made Matsu the "sacrificial system" of Taiwan's main island, sacrificing the freedom of being unstrained of the residents and the landscape and also replacing the island's daily life with a long wait and preparation for war. It was not until 1992 when the martial law was lifted that Matsu's voice started to emerge bit by bit. Tsao Yixiong, the owner of the Thorn Bird Café and Bookstore, a former legislator, and a former director of the Council for Cultural Affairs, once said, "To me, Taiwan is my offshore island." This is where the master/slave debate between Taiwan and Matsu rises. Over the past thirty years, the local voice of Matsu has become a brand-new proposition for the "Matsu dream" after the role as the war zone administration was lifted.

When Islands Dream utilizes the role of "dreamers" borrowed from local people's actual religious practice, similar to a medium for divining destiny, and uses bodies of dream and mediums of five non-Matsu artists who felt and received sounds and images in Matsu to help divine and interpret the dreams of the islands. When we look at the works of Wang Yu-Song, Sean Trudi Hsu, Huang Hsiang-Yun, Yannick Dauby, and Emma Dusong in the context of John Wylie's Landscape Phenomenology, Chapter 5 of *Landscape*, we can see that the exhibition focuses on the curatorial perspective of returning to the "bodily subject." The exhibition provides a rich interweave of visual, acoustic, and embodied threads, highlighting the artists' commitment to the experience of the Matsu Islands, rather than just reflecting on it from a distance. This approach allows the audio-visuals on display to be immersed in the contextual world of Matsu, including its grass bushes, coasts, tunnels, bunkers, shotguns, and the Eastern Min language, as well as in a world unfamiliar to outsiders, "creating space" with different dream media to engage in direct dialogue with and adaptation to the Matsu world around them.

The first piece of work is Sean Trudi Hsu's *Winding Islands, Revolving Dreams*. In the Matsu landscape, the artist creates two bodies that wander in dreams. Perhaps this is related to the tense situation of the pandemic and the artist's precarious conditions while in residence. Hsu says that he "wanders around the Matsu landscape in a dreamlike

manner, in an inhuman posture. Walking through tunnels, old houses, sea rocks and roads, the waves surround the spikes around Matsu, pushing the sleepwalker back into the tunnels again, and so on and so forth." The sense of depression sent out by the white-colored bodies in the images reminds us of the depressed young bodies in the images of photographer Chang Chao-Tang in the 1960s and 1970s. Of course, we can say that the lack of actual experience of living on the islands, or even the pressure of creating under the condition without sufficient materials and time, may be one of the sources of this depression. However, more than one artist has told me that when they repeatedly entered and left the different stronghold tunnels, going back and forth in the intersection of darkness and light and facing the empty sea, they gradually felt like vomiting. For Taiwanese who have no living experience on the islands, what does Matsu mean if its role as a tourist destination is removed? Sean Trudi Hsu's interpretation of sleepwalking not only reflects the physical bodies of the military personnel who used to appear in these strongholds, but also resembles the distorted bodies of Japanese Butoh dancers who are immersed in ominous places with no way out. Here, the ominous place is replaced with abandoned military strongholds that are not a home or a foreign land, but with a pair of sleepwalkers in a maze resembling Kafka's castle, following a dark passage without any end or answer while facing a coastal landscape without any movement or scenery.

The second is Wang Yu-Song's *Days in the Lighthouse*, a body of the keeper that remains, a body that spends its days and glows in the lighthouse. For Matsu, "waiting" is one of the longest nightmares, and "waiting" is also a normalized daily state of mind- -waiting for the war to come, waiting for supply goods to come, waiting for the bad weather to end, and waiting for the fog to clear. What comes again and again is the same endless "waiting." Wang Yu-Song transforms this "waiting" image of time into an actively selected cyanotype. He transforms his own body into the ever-moving Dongju Lighthouse, using the lighthouse keeper, the lighthouse itself, and the light of the lighthouse to symbolize the dream of Matsu. Extending from his creative lineage of the White Lighthouse in Hualien, Wang Yu-Song's work allows the viewer to detach themselves from the depressed body of a sleepwalker and transform it into the body of the lighthouse keeper, which, although immobile, actually serves as an important guide. From the spiral staircase in the interior space of the lighthouse to the small door that the lighthouse keeper uses to enter and exit the lighthouse, from the outline of light to the sea surface that the land path and the sea route point to, Days in the Lighthouse emphasizes a luminous body that glows persistently and gently in the darkness. If this is another dream of the islands, its image appears truly calm, but we can also imagine the

intensity of time and space as it battles the wind and fog with light beams in the midst of a violent storm.

And then, it is Huang Hsiang-Yun's work, *Memory Punctum: Photography & Cartography Workshop*. This is a tactile body in which participants can touch the rough stones in the Matsu tunnel, the spiked structures of the cannon room for silencing sound, and the spiked edges of the agar plant, in dialogue with the tension of the landscape and the body's tactile memory. This workshop emphasizes tactile reading of the bodily landscape, which is something that is almost completely ignored in general exhibitions. Thus, this arrangement actually shows that the curators have given a great deal of weight to the development of a dialectical dialogue between the body and the landscape in their methodology. The artist leads the workshop participants to collect rocks from places of significance to them, to experience the texture of the tunnel with their senses and bodies, and to recall the Matsu landscape in their own stream of consciousness, creating a 'mental map' that integrates feelings, memories, and imagination. In the process of transforming the tactile sensations of the landscape into images, he brings in the reading experience of these detailed spikes. Through such method, Huang Hsiang-Yun implements the "psychogeographic" collection of spikes in the landscape, forming a tactile narrative.

In Yannick Dauby's *She heard nothing in Matsu. She heard everything*, the editing and narrative focus on the soundscape itself, allowing the fixed images of Matsu to begin to flow like memories and dreams. This is how I felt after returning from Matsu and re-watching the works several times. Because of the close proximity of the quality of the recording, we were suddenly able to calm down and enter the space of a very low-speed "diary tape," whether we were in a tunnel, amidst the sound of cicadas, broadcasting from the shore, walking in a trench, listening to the sound of sand being pumped, listening to the Eastern Min dialect, or listening to the narratives of the islanders being interviewed. This "diary tape" no longer broadcasts the boring sounds of political propaganda, or even when the old sounds of political propaganda appear, in the context of the changing soundscapes and narratives, they become a dreamlike and fascinating sense of nostalgia. However, the narrative of this contemporary Matsu soundscape is intertwined with the islanders' worries and anxieties among the past, present and future. We hear several different states of mind, and in the interplay of these memories, uncertainties about the present, and doubts about the future, the various cicadas and birds become unusually clear, and the shivering sounds of passing through the landscape and the tunnels become unusually tangible. While the medium of sound, led by an

unknown female ghost, travels through Matsu's different memories of time and space, as well as all things and landscapes that form a soundscape world of polyphonic repertoire, Matsu's dreams flow in a fluid manner between the land and the landscape in the form of micro-objects.

Lastly, *Mĕing-hyong nȳ (Facing You)* by Emma Dusong is a poem about dreaming that confronts the audience with the juxtaposition of audio and visual bodies of dream. The artist attempts to compose music for three islanders in the medium of Matsu's Eastern Min Dialect, a variety unfamiliar to Taiwanese, "Facing you / When we sleep / We dream / When we dream / We question / When we question / We stand up / When we stand up / We are motivated / We are." In the audio-visual context of the piece, the three islanders are shown asking their own questions, standing, but projected on the mattress so that they seem to float on the mattresses and rise up like monoliths, forming a triptych as if they were in a church. As one of them sings, the other two resurface, suggesting the evocative power of the song and creating a collective energy of proclamation. Interestingly, while the residents of Matsu are sleeping, due to the time difference, the artist is singing from the shores of the Mediterranean Sea in France, echoing the sea in Matsu. Emma Dusong does not shy away from her identity as a foreigner, an identity that is vulnerable to the pandemic as it blocks her presence in a distant land. While the Dreaming Ceremony usually focuses on the visual images, here the artist turns her attention to the sounds and chants of the locals. The questioning poetic sounds seem to echo the chirping of cicadas and birds and the lapping waves of the coasts of Matsu in *She heard nothing in Matsu. She heard everything*. Yet, *Mĕing-hyong nȳ (Facing You)* or even the entire exhibition *When Islands Dream* goes further, penetrating the states of mind presented in the dreams and transforming the ancestry of the Matsu islands into a question or a series of inquiries in the deepest bottom of the dreams. This incomparable audio-visual poetic landscape allows us to face our existential fears.

(This article first published in *Artist* Magazine No. 562, 2022 March Issue.)

Epistemology of Dreams: A Review of When Islands Dream

夢的認識論：
評《如果島嶼會作夢》

陳平浩
Chen Ping-Hao

影評人
Film Critic

中華文化總會與連江縣政府合辦的《島嶼釀‧馬祖國際藝術島》展覽在馬祖盛大開幕的前
夕，台北當代藝術館（MoCA Taipei）也有一個關於馬祖的展覽。這個規模小但後勁並不
小的展覽叫作《如果島嶼會作夢》，是策展人謝宇婷第一次策展。她從馬祖北竿「祈夢」此
一獨特習俗獲得靈感，在摸索如何策展的過程裡，邀請五位藝術家化身「代夢人」，以各自
擅長的迥異媒材「代替馬祖作夢」。

金馬離島從冷戰戒嚴時代起好幾十年作為「戰地前線」（既是被砲擊之地也是砲灰之地），
歷經比臺灣本島晚了好幾年才解嚴（1992 年），再經歷 1990 年代本土化浪潮裡出現的「金
馬放棄論」（或「金馬撤軍說」），接著國民黨復辟之後因為生計往來而（被迫）「親中」，最
後隨著近年新冷戰局勢與「防疫如作戰」而再度喊出「同島一命」口號（現實則是既不同島
也不同命）。這時，卻有一個關於馬祖的展覽以「作夢」為題，真的很不政治──但此時此
刻，這也許反而是最政治的。

展覽裡的作品共享一個特點：高度聚焦於「個體的感官」。

舞踏藝術家許生翰的行為藝術紀錄影片〈島迴〉，讓全身塗白的身體在馬祖的邊沿遶巡，一
邊走路攀爬一邊四處摸索。舞者始終緊閉雙眼（剝奪視覺、僅剩觸覺），以身體摩擦沿岸粗
糙石塊與木麻黃葉片，以指尖或趾尖（像觸角似的）探觸粉牆與石隙、樹幹與葉尖。粉白身
體既像「另一種雕像」（因此是「反偉人雕塑」的）也像美術教室裡的石膏像──在一種素描
的姿態與形色裡，舞者身體「幾乎」（所以「尚未」或「始終尚未」）與周遭融合，因而既同
一又外在，既摹擬也形塑。即使馬祖的岩岸、沙灘、坑道都入鏡了，但舞者似乎總是只能
遊走在馬祖的邊沿（灘岸、防風林、堤防、面海的觀景台），似乎總在碉堡開口的窗洞（或
礮眼）重複進入與退出的動作──似乎永遠無法真的進入馬祖。

接下來的展間也有以觸覺為核心的作品。〈記憶刺點：攝影與製圖工作坊〉，乃是黃祥昀邀請馬祖居民參加「地景體驗」工作坊的成果：藝術家以一冊書本的形式，同時以「印刷鉛字」與「盲人點字」記錄了個別居民在工作坊口述的「地景」。羅蘭巴特（Roland Barthes）討論攝影時所談的「刺點」，在此成為看不見但摸得到的「凸觸」或「突觸」（可參閱精神科醫師鯨向海的短詩〈警鈴〉）。

同一展間還有另一種「Siren」：艾瑪・杜松（Emma Dusong）的〈面向汝（Měing-hyong nỳ）〉以臺灣本島人乍聽之下更像「聲音」而不像「語言」的馬祖話（包括剛被列進中小學本土語言課程的閩東話）為三位島民作曲，展場裡三屏幕（或三聯畫）上的島民閉上雙眼、交互輪唱——幾乎像是海妖塞蓮（Siren）在唱歌。然而，這些歌曲皆是召喚島民返鄉的家園記憶，而不是誘惑水手遠離家鄉、進而掉入陷阱的靡靡之音——因此剛好悖反於戰時的「心戰喊話」。

這些聚焦「觸覺」與「聽覺」、甚至逼近「反視覺」的作品，像是一方面「反觀光」（消費主義與資本主義）另一方面「反監視」（國家、政治、戰爭）。這在另一個改採「視聽」作為經緯的展間裡，有更繁複的辯證。

王煜松〈在燈塔的日子〉以藍曬圖呈現東莒的燈塔。非常奇妙，這件作品的邏輯和莫泊桑（Maupassant）所言「全巴黎唯一看不見艾菲爾鐵塔的地方，就只有在艾菲爾鐵塔上」剛好完全相反——這件作品只有燈塔，而沒有從燈塔上理應看見（而且是全觀俯瞰甚或全面監視）的小島地景與小島周邊海面風景。藍曬圖上只有燈塔裡的巨大燈泡、放大鏡（用以增幅亮度）、建築結構（比如鑄鐵迴旋梯）、鐵門，頂多入鏡一點點周遭景物，以呈現燈塔坐落的位置。就像羅柏艾格斯（Robert Eggers）的恐怖片《燈塔》（The Lighthouse，2019），觀眾最想看見的最終就是不讓你看見——但你可能看見了「最闇黑的光」。

聲音藝術家澎葉生（Yannick Dauby）的〈在馬祖，她一無所聞。她聽聞一切。〉是一部非常精彩的紀錄短片。他將馬祖居民的訪談、島嶼的環境音、以及島上的影像彼此交錯——而且是一種縝密的、辯證的影音交錯。

三種模式的影音規律輪放：一，黑畫面、畫外環境音、以及聲軌上居民談論著「馬祖的聲音」的話語聲。二，黑畫面配上字幕（黑底白字）、環境音、字卡講述作品題目裡「她」的遊歷。三，攝影靜照與環境音。這三種模式分別是三種音畫關係、而三種模式之間又再進一步組成了多組音畫關係。層層折疊、繽紛繁複。

於是觀眾聽見以下這些聲音以及受訪者談論這些聲音的話語聲：蟬噪、潺潺水流、村子裡的廣播、Ampex 705 低速錄音磁帶、電磁波、天后宮的祈福吟唱、馬祖人的大嗓門、輪船馬達聲、抽砂船引擎聲、海鳥、蛙鳴、鑿石補牆聲、洗牡蠣殼聲、70 年前心戰喊話錄音檔（「她」在廢墟教堂撿到的）、廟會鼓板（節奏不同於臺灣，模擬福州方言）、空襲警報鳴笛聲（與防空洞裡的嗡嗡）、近海演習砲擊聲、兩座揚聲器的心戰喊話被海浪扭曲吞吃的變音——而漁民們聽見「國家之間」的聲音、海洋生物聲、或海妖的歌聲……。

澎葉生借影片裡的靈媒之口（以福州話）說：「光和聲是平等的。」而且「鳥在錄音，並且將會世代傳遞下去。」詩意而神秘的敘事，讓人不禁猜想，那個不知何時早已死去、但又重遊島嶼、最後「終於抵達了海」的「她」，究竟是誰？片名〈在馬祖，她一無所聞。她聽聞一切〉讓我想起了澎葉生的家鄉法國曾經有位名叫亞倫・雷奈（Alain Resnais）的導演拍攝的《廣島之戀》（Hiroshima mon amour，1959）：法國女子說她在廣島看見了這個、看見了那個、還看見了另外那個……但日本男子堅決否定：不，在廣島妳什麼都沒看見。或者，澎葉生這個作品裡的「她」居然是林默娘（左右有千里眼與順風耳）或者聶隱娘（有三個耳朵，而且佩刀）嗎？

這個展覽裡的作品皆以感性的感官經驗觸發與生成，有一種「在這之前我對馬祖一無所知（因為種種政治原因，從戒嚴時代森嚴海防到解嚴後的金馬放棄論），如今我開始以我的感官與身體去接近它」的謙遜、誠懇、與好奇，絲毫沒有「我以我的歷史來認識你的歷史以及你與我的歷史」或「好，我要來和你確立關係、確定相對位置、確認未來的共同版圖了」的急躁（甚或粗暴）——也許這是因為這個展覽的認識論是「夢」，藝術家不是來馬祖「驅逐惡夢」（這個島嶼過去、現在、甚至未來的惡夢），藝術家也不是來馬祖「承諾夢想」（更好的生活、更發達的經濟），藝術家是來馬祖「作夢」的，而且是「代夢」、不是「代言」。

於是，我想起了紀錄片導演黃庭輔返回故鄉金門拍攝的實驗電影《03：04》（2000）與《島》（2012），是關於金門人與「時間」、金門人與「鬼魂」的關係；藝術家林羿綺短片《雙生》（2020）裡的金門則是「印尼」與「臺灣」之間的關係；導演董振良多年以來以金門為主題的紀錄片則是他這個金門人與金門的關係、他這個金門人與自己（的脾性或脾氣）的關係——很奇妙，都不是「臺灣與金門的關係」，而是「島與島與人的關係」。

因此，《如果島嶼會作夢》這個展覽也令我忽然強烈想起了童偉格的長篇小說《西北雨》。從沒想過會有一個當代藝術的展覽，以視覺、聽覺、觸覺與身體，如此貼切地（貼著感官、貼著身體）再現了這一本從頭到尾都沒有提過馬祖的小說——只有冬季的霧，夏日的灼燒，如夢境的奇遇，海浪天空與防風林，不斷的折返與繞圈，生而為人因此創傷累累千瘡百孔的心靈史，以及反覆的離去與抵達。

On the eve of the grand opening of the inaugural Matsu Biennial *Island Brew* in Matsu, held by the General Association of Chinese Culture and Lienchiang County Government, the Museum of Contemporary Art Taipei (MOCA Taipei) also had an exhibition themed around Matsu. This small but powerful exhibition is called *When Islands Dream*, and it is curator Hsieh Yu-Ting's first exhibition. Inspired by the unique custom of the Dreaming Ceremony in Beigan, Matsu, she invited five artists to take on the role of "dreamers" in the process of figuring out how to curate exhibitions, with each of the artists using a different sensory medium of specialization 'to dream on behalf of Matsu.'

When Kinmen and Matsu went from being a front line of war (as both a place to be bombarded and a place of ashes) for decades during the Cold War and the local martial law era, to being demilitarized several years later (1992) after the martial law period in Taiwan ended(1987), to being placed under the Kinmen-Matsu Abandonment Theory (or Kinmen-Matsu Withdrawal) framework that emerged during the 1990s localization wave, then to being subject to the (forced) pro-China attitude for a living after the Kuomintang (KMT) was restored to power, and finally to being coined by the pro-China attitude of the new Cold War and the slogan of "Fight the virus as a war" in recent years with the new Cold War and the slogan "One island, one life" (in reality, it is neither the same island nor the same life as Taiwan Island). An exhibition on Matsu exploring "dreaming" is quite apolitical - but perhaps it is the most politically loaded of all at this moment.

The works in the exhibition share a common characteristic: their foci are strongly about 'the senses of individuals.'

Butoh artist Sean Trudi Hsu's performance art documentary *Winding Islands, Revolving Dreams* features bodies painted white that wander around the edges of Matsu, walking and crawling while groping around. The dancers keep their eyes closed (deprived of sight and left only with the sense of touch), rubbing their bodies against the rough stones and jute leaves along the shoreline, and using their fingertips or toe tips (like tentacles) to touch the lime walls and stone gaps, tree trunks and leaf tips. The white bodies stand as an anti-hero statue to the dictator's statues all over the island, resemble the plaster casts in the art classroom—in a sketched gesture and form, the dancers' bodies 'almost' (and therefore 'not yet' or 'yet to come') merge with their surroundings, and are thus both homogeneous and heterogeneous, both mimesis and metamorphoses. Even though Matsu's rocky shores, beaches, and tunnels are all in the scenes, the dancers always seem to be able to wander around the edges of Matsu (beaches, windbreaks, embankments, and sea-facing observation platforms), and seem to repeat the actions of

entering and exiting at the openings of bunkers (or the eyes of the ounce of light)—as if they can never really enter Matsu.

The next gallery room also features works with the tactile sensation as the core. *Memory Punctum: Photography & Cartography Workshop* is the result of a workshop on 'landscape experience' in which Huang Hsiang-Yun invited Matsu residents and collaborated with them: in the form of a book, the artist recorded the 'landscapes' that individual residents verbalized afterwards, using both printed pencils and Braille. Here, the 'punctum' that Roland Barthes talked about when discussing photography have become invisible but palpable protrusions or synapses (see the short poem *Siren* by psychiatrist-poet Xiang-hai Jing).

In the same exhibition room, there is another kind of Siren: Emma Dusong's *Mĕing-hyong nȳ (Facing You)* is composed for three islanders in the Matsu language, which sounds more like a 'voice' than a 'language' at first glance to the people of mainland Taiwan[1], and the islanders in the three screens (or triptychs) in the exhibition hall also sing and then close their eyes in turn—almost as if the Siren is singing. However, these songs are a call to memories of home, not a sappy sound that lures sailors away from home and into a trap— thus contradicting the propaganda.

These works, which focus on 'touch' and 'hearing' and even approach 'anti-vision,' seem to be 'anti-tourism' (consumerism and capitalism) on the one hand and 'anti-surveillance' (state, politics, war) on the other. There is an even more complex debate in another exhibition room where sight and sound are employed as the latitude.

Wang Yu-Song's *Days in the Lighthouse* presents the lighthouse of Dongju in a cyanotype. The logic of this work is the exact opposite of "the only place in Paris where you can't see the Eiffel Tower is from the Eiffel Tower" (in Maupassant's words)—this work only has the lighthouse, without the view of the island and the sea around the island that the lighthouse is supposed to see, which is in fact a holistic view or even an overall surveillance. The cyanotype only shows the huge light bulb in the lighthouse, the amplifier (to increase the brightness), the architectural structures (such as the cast iron spiral staircase), the iron gate, and at most a little bit of the surrounding landscape to show the location of the lighthouse. Like Robert Eggers' horror film, *The Lighthouse* (2019), what the viewer wants to see is ultimately absent—but you may actually see the 'darkest light.'

Sound artist Yannick Dauby's work *She heard nothing in Matsu. She heard everything* is a wonderful short documentary. He interlaces interviews with residents of Matsu, ambient

sounds of the island, and images of the island—and it is a meticulous, dialectical interplay of audio and video.

Three modes of audio-visual regulation are played: first, a black screen with off-screen ambient sound and the soundtrack where the residents talk about "the voice of Matsu" ; second, a black screen with subtitles (white texts on a black background), ambient sound, and word cards describing 'her' travels in the title of the work; third, still photographs with ambient sound. These three modes are three types of audio-visual relationships, and they further form multiple sets of audio-visual relationships among themselves—multilayered, enriched, and intricate.

As a result, the audience hears the following sounds, as well as the voices of the interviewees discussing the sounds: cicadas, rushing water, village radio, Ampex 705 low-speed tapes, electromagnetic waves, the chanting of blessings at Mazu Temple[2], the loudness of Matsu people, the sound of ship motors, the sound of sand pumping boats, sea birds, frogs, stone mending, oyster shucking, a recording of heartfelt war cries from seventy years ago (which 'she' found in a ruined church), and the sound of a frog. The sound of a siren call (and the buzzing of an air raid shelter), the sound of artillery fire from an offshore exercise, the distorted sound of two speakers' war cries being swallowed by the waves—and fishermen hearing "interstate" sounds, the sound of marine life, or the song of a siren

In the words of a shaman in the film, Yannick Dauby says (in Matsu dialect), "Light and sound are equal." Additionally, "the birds are recording everything and will pass it on for generations." The poetic and mysterious narrative makes people wonder who the 'she' is that died long ago but traveled around the island and finally reached the sea. The title of the film, *She heard nothing in Matsu. She heard everything*, reminds me of Alain Resnais's masterpiece, *Hiroshima, mon amour* (1959). In the film, a French woman says she sees this and that and others in Hiroshima, but the Japanese man firmly denies it by saying, "No, you saw nothing in Hiroshima." Or, is the 'she' in this work by Yannick Dauby actually Sea Goddess Mazu (with her two guardians, "Thousand-Mile Eyes" and "Fair-Wind Ears") or Nie Yinniang in *The Assassin*(2015) (with three ears and a dagger, as Hou Hsiao-Hsien says).

The works in this exhibition are all triggered and generated by sensual sensory experiences, with the humbleness, sincerity, and curiosity that 'I knew nothing about Matsu before this (for various political reasons, from the strict maritime defense during the martial law era to the Kinmen-Matsu abandonment theory after the lifting of martial

law), but now I am beginning to approach it with my senses and my body.' Rather than the abrupt attitude of 'I'm coming to establish a relationship with you, to determine my relative position, to confirm our common map for the future.' Perhaps this is because the epistemology of this exhibition is 'dream,' and the artist did not come to Matsu to 'chase away the nightmares' (the nightmares of the island's past, present, and even future), nor did the artist come to Matsu to make any promises of 'dreams-come-true' (a better life, a more prosperous economy); instead, the artist came to Matsu only to 'dream,' and to 'dream on behalf of others' rather than 'speak for others.'

Thus, I am reminded of Huang Ting-Fu's experimental films *03:04* (2002) and *Island* (2012), which are about the relationship between the Kinmen people and 'time' and between the people of Kinmen and 'ghosts'; the relationship between Indonesia and Taiwan in Lin Yi-chi's *Doppelganger* (2020); and Dong Cheng-Liang's years-long making of documentary films on Kinmen. The relationship between Kinmen people and Kinmen, and between Kinmen and the director himself (especially his temperament or temper) are interestingly not about the relationship between Taiwan and Kinmen, but one that is between 'this island' and 'that island' and their people.

Therefore, the exhibition *When Islands Dream* also reminded me strongly of Tong Wei-Ger's novel *Northwest Rain*. I never thought there would be a contemporary art exhibition that reenacted this novel about Matsu (yet never mentioned it in the book) in such an intimate way (close to the senses, close to the body), using visual, auditory, tactile, and physical senses—with winter fog, summer burns, dream-like encounters, sea and sky and windproof forests, constant turning and circling, the traumatic history of the heart and soul of being born as a human being, and the repetitive departure and arrival.

1 The Eastern Min language was not allowed in Matsu schools during the Martial Law Period. It was not until 2022 that it became mandatory courses in the schools of Lienchiang County.

2 Mazu is the name of the sea goddess who is widely worshipped throughout China's coastal regions and overseas Chinese communities throughout Southeast Asia. The name of Matsu islands is also derived from the goddess as it is believed that Mazu's corpse floated to the coast of Matsu and ascended as a goddess on the islands.

When We Curate in Matsu: How to work with the Community?

當我們來到馬祖策展——
走進地方的工作心法分享

座談｜在地方策展：當我們來到馬祖
時間｜2022年1月23日 13:00-15:00
地點｜台北當代藝術館大廳
主持｜謝宇婷
講者｜廖億美、林怡華
記錄｜田偲妤

Talk｜Curating for a Place: When We Arrive in Matsu
Time｜Jan 23, 2022 13:00-15:00
Venue｜MoCA Taipei Hall
Host｜Hsieh Yu-Ting
Speaker｜Liao Yi-Mei, Eva Lin
Summary｜Sally Tian

《如果島嶼會作夢》是謝宇婷在台北當代藝術館（MoCA）策劃的展覽，透過藝術家的轉譯，將馬祖北竿的祈夢習俗、戰地歷史和文化地景帶至臺北。馬祖在此成為主角，翻轉首都和離島長期的不對等關係。然而，非馬祖人應該用什麼樣的態度接觸馬祖？如何讓臺北的觀眾認識馬祖？如何讓馬祖人理解並走進藝術場域？謝宇婷在思考上述問題之際，特別邀請在馬祖有豐富策展經驗的藝術工作者廖億美、林怡華，分享在地方策展的歷程。

天黑後的無人禁地——東莒大埔村的重生故事

好多樣文化工作室主持人廖億美，早從1996年便接觸馬祖，她還記得首次登上東莒島時，只見滿坑滿谷的士兵。矛盾的是，長期處於備戰狀態的馬祖卻從未開戰，只留下無數的戰地建設與戒嚴歷史，對居民的生活產生深遠影響。

2008年，廖億美再次來到東莒，這是一座只有100多位居民、馬祖唯一沒有鄉公所的島嶼，淳樸的鄉村卻流傳一個神秘的禁忌。島嶼的另一端有處名為大浦的聚落，漁業盛行時代，曾是百商雲集之地，不幸於1970～1980年代沒落，直到2000年最後一位居民離開，大浦就此淪為天黑後無人敢踏入的禁地。

如何讓大浦再次回到居民的生活中？廖億美和團隊決定發起「藝術轉場計畫」，邀請藝術家到大浦駐村，以肉身實驗怎麼在廢墟間生活。隨後更在2010年展開「換生活計畫」，來自不同領域的夥伴在此學習過小島人的生活。東莒有句話叫「大海是我的冰箱」，大夥到海邊釣魚、抓螃蟹、採集螺貝類，或是帶著空袋子去找島上的媽媽們聊天，通常能滿載而歸豐富的食材。大浦逐漸成為快樂的小島遊樂場，翻轉居民對此地長久以來的負面觀點。

為了和居民有更多互動，「交換禮物計畫」應運而生，藝術家前來聆聽居民的故事，再運用眼睛、雙手、心靈，編織並訴說另一個故事。有段時間，東莒的廣播器常傳來這樣的宣傳：「今天晚上在電影院有人唱歌」、「今天晚上在菜園有人跳舞」。就這樣，客家歌手的演唱會勾起阿姨在電影院談戀愛的回憶，舞者的肢體律動釋放菜園阿嬤勞動已久的身軀。有一天，島上的媽媽們甚至帶著紅糟料理，走進許久不敢踏進的大浦，在日落餘暉之際，一場紅糟盛宴熱鬧展開，一段眾人共創的新大浦故事就此流傳。

給逝者的展覽──翻出埋藏地底的歷史記憶

山冶計畫藝術總監林怡華，因「馬祖國際藝術島」而來到馬祖，她回憶起家人得知自己剛從馬祖回來的反應：「為什麼妳不用隔離？」可見對某些臺灣本島人來說，馬祖是個陌生的境外之地。而馬祖本身也有其狀況，林怡華察覺，馬祖人在樂觀認命的表象下，心中似乎埋藏著難以言說的記憶，在長期等待戰爭的生活中，一股無形的壓力潛藏在心靈深處。

因此，林怡華默默在心裡設下隱形的目標觀眾：那些在這片土地上逝去的人。藉由在南北竿所策展的《地下工事》展覽，翻出埋藏多年的歷史記憶，慰藉因長期備戰而身心被禁錮的軍民們，也希望讓更多人理解馬祖的特殊處境。

77 據點是向地底開鑿的軍事坑道，長年黑暗、潮濕，非常不適合作為展覽空間。林怡華試圖將場地缺點變成展覽要件，例如丁建中的〈靜候之景：馬祖列嶼〉以感濕油墨印製攝影作品，待空氣中瀰漫水氣時，覆蓋的影像才會浮現。陳飛豪的錄像作品〈水流之神〉，在黑暗的坑道內講述馬祖沿岸供奉水流屍的在地信仰，與觀眾共同思考馬祖的主體想像重新建構的可能性，馬祖不僅是戰地前線，還有更多層次的敘事線尚待被發掘。而在北竿后澳村修復的閩東式民宅裡，邱承宏的作品〈採光〉正在行光合作用。藝術家從坑道的射口附近採集各種植物與和居民所種植的盆栽，以雕刻方式呈現在牆上。窗外灑入的陽光產生多樣的光影，讓長期在底層求生的植物能自由吸收陽光，更象徵埋藏在地下的記憶將重新問世。

在外地與當地策展需留意的問題

在了解廖億美、林怡華在馬祖工作的心路歷程後，策展人謝宇婷提出自己面對的最大困難：「展覽跟馬祖有關，卻不在馬祖展出，而是在臺北的美術館空間，想請教兩位怎麼看待這次在美術館做的展覽？」

廖億美從研究馬祖的戰地空間和歷史切入討論，馬祖的戰備地景可以說是好幾個世代共同完成的暗黑創作，在踏查地景空間時，她不自覺地對過去軍人與居民的心理狀態產生好奇。後來她也接觸到馬祖的白色恐怖歷史，有感於外來者無法代替當地人承受創傷，所能做的就是把這段歷史好好說出。而對於這次的展出作品，她認為比起藝術家的代夢轉化，如何把當代藝術作品帶回馬祖，讓居民的記憶、感受與藝術家營造的空間氛圍銜接，將更具挑戰性。

林怡華則習慣每次策展時在心裡設想一個對話溝通的對象，如此有助不斷反省、調整、提問：藝術離開白盒子空間的內涵意義是什麼？展覽要傳達什麼訊息？想跟誰對話？對林怡華來說，地方文化不應淪為創作素材而已，反倒是我們如何透過作品去敞開地方更多元的認識論。她也進一步對美術館空間展示的型態提出建議，如果能讓觀眾對馬祖北竿的祈夢文化有基礎的認識，藝術的轉譯會更具意義。

近年來在政府單位的帶動下，馬祖以藍眼淚、紅糟料理、戰地景觀等多元樣貌展現在眾人眼前。在絢麗的觀光包裝下，我們也別忘了馬祖人長期壓抑的歷史創傷，藝術的介入除了促進地方發展，也需顧及並尊重當地居民的感受。

When Islands Dream, curated by Hsieh Yu-Ting for the Museum of Contemporary Art Taipei (MoCA), brings the Dreaming Ceremony of Beigan, war history, and cultural landscape of Matsu to Taipei via the interpretation of various artists. Matsu becomes the protagonist, reversing the long-standing unequal relationship between the nation's capital and its outlying islands. However, how should non-Matsu natives approach Matsu? How can the audience in Taipei get to know Matsu? How can Matsu natives understand and enter the art scene? Hsieh invited experts with extensive experience in fieldwork, social construction, and curating in Matsu: Liao Yi-Mei (Director of the Cultural Diversity Studio) and Eva Lin (Artistic Director of mt.project) to share their working experiences in Matsu and discuss the questions above.

The Forbidden Land After Dark — The Story of Rebirth in Dongju Dapu Village

Liao Yi-Mei still remembers the first time she visited Donju Island in 1996, when she only saw a sea of soldiers. Paradoxically, Matsu has never been at war, leaving behind a

history of countless battlefield construction and martial law restrictions, which has had a profound impact on the lives of the residents.

In 2008, Liao Yimei returned to Dongju, an island with only 100 residents and the only island in Matsu without a village office. At the other end of the island is a settlement called Dapu, where hundreds of merchants once gathered during the prosperous days of the fishing industry, but unfortunately fell into decline from the 1970s to the 1980s. When the last resident left in 2000, Dapu became a forbidden place where no one dared to enter after dark.

How to bring Dapu back into the lives of Dongju residents? Liao and her team decided to initiate the "Art Transition Project," inviting artists to do residency in Dapu and experiment with how to live among the ruins. Later, in 2010, they started the "Life Exchange Project," in which people with different backgrounds learn to live the life of the islanders. There is a saying in Dongju that "the sea is my refrigerator." People go to the sea to fish, catch crabs, collect shellfish, or bring empty bags to talk to the mothers on the island, and usually return with plenty of ingredients. Dapu gradually become a happy playground for the islanders, reversing the long-held negative perception of the area.

In order to have more interaction with the residents, the "Gift Exchange Project" was created, in which artists come to listen to the residents' stories and then use their eyes, hands, and hearts to weave and tell a different version of the stories. For a while, the broadcasters in Dongju would say: "Tonight there will be singing in the cinema" or "Tonight there will be dancing in the vegetable garden." The singing of Hakka singers evoked the romantic memories of aunties in the cinema, and the body rhythms of dancers would release the labored bodies of grandmas in the vegetable garden. One day, mothers on the island even brought red vinasse dishes to Dapu, where they had not dared to go for a long time.

An Exhibition for the Departed - Uncovering the Buried Histories

Eva Lin came to Matsu due to the inaugural Matsu Biennial. She recalled her family's reaction when they learned that she had just returned from Matsu: "Why don't you need to quarantine?" It is clear that Matsu seems to be a foreign place for many living in Taiwan. Lin noticed that, underneath their optimistic and submissive appearance, the people of Matsu seem to have buried memories that are difficult to explain, and that an

invisible pressure lurks deep in their hearts as they have prepared for war for such a long time.

Therefore, Lin silently sets an invisible target audience in her mind: those who have passed away in this land. Through the exhibition Underground Matters at Nangan and Beigan, she unearths histories that have been hidden for many years, comforting the soldiers and residents who have been physically and mentally imprisoned due to prolonged war preparations, and hoping that more people will understand the unique situation in Matsu.

Stronghold 77 is a military tunnel cut into the ground, which has been dark and damp for years and is very unsuitable as an exhibition space. Lin attempts to reverse the shortcomings of the venue into an essential element of the exhibition. For example, Ding Chien-Chong's *The Elapse: Matsu* was printed with special humidity-sensitive ink so that the image of the sea only emerges when the air is humid; Chen Fei-Hao's *God Flowing in the Water* is a video work that tells the story of the Matsu custom of worshipping the corpse of water flowing along the Chinese coast in the darkness of the tunnel. The work invites audience to ponder on the possibilities of reconstruct the sovereign imaginary of Matsu, which is not only the front line of the battlefield, but also has more layers of narratives yet to be explored. In a restored Eastern Min house in Houao, Beigan, Chiu Chen-Hung's work *Daylighting* is undergoing photosynthesis. The artist collected various plants from the vicinity of the tunnel as well as pot plants grown by villagers and sculpted them on the wall. The sunlight pouring in from the windows transforms into various shades of light, allowing the plants that have been surviving on the ground floor for a long time to absorb the sunlight freely, and symbolizing the reappearance of buried memories.

Issues to be Aware of When Curating for Local Communities

After learning about Liao's and Lin's experience in Matsu, curator Hsieh Yu-Ting raised the biggest difficulty she faced: The exhibition is related to Matsu, but it is based in an art museum in Taipei and not Matsu. How do they think of *When Islands Dream*?

Liao first responded from her perspective of researching Matsu's battlefield space and history. She described Matsu's battlefield landscape as a dark creation by several generations, and she became curious about the psychological state of the military and residents in the past when she stepped into the space. Later, she also came across the

history of the White Terror in Matsu, and felt that outsiders could not bear the trauma on behalf of the locals, so all on could do was to tell their stories. Regarding the works on display, she believes that it will be more challenging to bring contemporary artworks back to Matsu and allow the residents to feel connected with the atmosphere and sensation created by the artists.

Lin, on the other hand, is accustomed to communicating with the imaginary audience in her mind each time she curates an exhibition, so that she can constantly reflect, adjust, and ask: what is the purpose of a non-white-cube exhibition? What message does the exhibition want to convey? Who do you want to talk to? For Lin, local culture is not just a source of creative material. What's more crucial is how we can open up a more diverse epistemology of the place through the artworks. She also made further suggestions on the display of museum exhibitions. If the audience can have a basic understanding of the culture of dreaming ceremony in Beigan, the interpretation of art becomes more meaningful.

In recent years, government agencies presented Matsu to the public by featuring its "blue tears" phenomenon, red vinasse cuisine, and battlefield landscapes. Yet underneath the glamorous promotion aimed at tourists, we must not forget the long-standing and repressed trauma of the Matsu natives. While artistic interventions can support local development, it must also take into account and respect the feelings of local residents.

掃描 QR Code 觀看講座影片
Scan the QR Code to watch
the Talk

Beyond the Mainland Taiwanese Experience: The Not-So-Common Matsu Daily Life

臺灣本島經驗以外：
並不「理所當然」的馬祖日常

座談｜回看馬祖：不為人知的白色記憶
時間｜2022年1月23日 15:30-17:30
地點｜台北當代藝術館大廳
主持｜謝宇婷
講者｜劉宏文、林傳凱
記錄｜林意真

Talk｜A Look Back at Matsu:
　　　The Unknown White Memories
Time｜Jan 23, 2022 15:30-17:30
Venue｜MoCA Taipei Hall
Host｜Hsieh Yu-Ting
Speaker｜Liu Hung-Wen, Lin Chuan-Kai
Summary｜Alexandra Lin

本次展覽講座「回看馬祖：不為人知的白色記憶」，邀請到馬祖本地的文史工作者及作家劉宏文，與中山社會大學助理教授林傳凱對談戒嚴時代下的馬祖故事及白色恐怖。

林傳凱一直致力於白色恐怖的研究及歷史鄉鎮化的工作，而當他把馬祖的白色恐怖檔案整理好並歸還當地時，這些史料深深地震撼了劉宏文。即便那是從小耳聞的故事，但檔案仍揭示了更為清晰具體而殘忍的過往，一個有別於流言蜚語的世界。這也是為何講座以劉宏文的舅舅──曹常來（1936-2020）──作為引子，因為在這個被迫捲入時代洪流的人身上，我們能看到馬祖近代歷史的縮影，也能清楚意識到那些檔案不只是資料，而是一個人真真切切的遭遇。在臺灣中心主義的史觀敘述下，我們難以在近現代臺灣史中看到馬祖的身影和當地人的聲音，而大眾對馬祖歷史的忽略，使得馬祖白色恐怖歷史到了2019年左右才開始出現一些公眾討論，可是攤開馬祖的歷史細讀，會發現馬祖實際上面臨的是比本島更嚴峻的時代張力。

在講座開始時，劉宏文首先幫聽眾梳理了1949年前後的馬祖歷史，以及自己舅舅被牽連其中的故事。回溯歷史，馬祖列島雖是中國沿岸重要的漁場之一，但作為帝國難以管理的不穩定邊陲，長期禁止任何人民移居。一直到民國時期因為飢荒，人們才開始陸續從閩東移居馬祖列島。所以說，1949年之前的馬祖，基本上與大陸的閩東地區有著同一種社會型態及文化，甚至是共享生活圈（包括貿易、漁業等），反而和臺灣社會沒有太大的關聯，並且有著極為不同的歷史經驗。

曹常來的經歷必須放在這個脈絡下去理解。故事得回到1950年代，當時雖然國民政府早已撤退至臺灣，作為前線的馬祖也設立馬祖行政長官公署，照理說應與對岸維持敵對關係，但實際上在1950年之前，馬祖與閩東地區的民間社會仍有密切來往。那時十多歲的

曹常來被家裡送去學補漁網的手藝，這是在閩東地區相當賺錢的行業，他與師傅自然頻繁地往返馬祖列島和對岸間工作。但就在1950年一行人去福州的梅花補魚網時，曹常來因韓戰爆發而意外滯留在對岸，就在試圖回馬祖家鄉的流浪過程中，他輾轉加入海上保安第一縱隊（以下簡稱海保部隊）。

話說海保部隊起源自馬祖的保甲制度，當時馬祖經常與對岸有貿易往來，但因為沿岸多凶險，因此保甲會收取保護費，讓漁船和商船安全進出馬祖列島，而這也是馬祖最後有組織的武裝力量。海保部隊並非正規軍力，而是地方集結的武裝集團，因此長期不受國軍重視，然而在韓戰開打之際，這個部隊卻擔負前線最危險的情報工作。當時美國中情局（CIA）為了獲得更多共產黨的情報，在馬祖成立了「西方公司」（the Office of Policy Coordination, OPC），並藉由能操福州話和馬祖話的海保部隊往返對岸蒐集情資。當時曹常來便是遇上在福州蒐集情報的海保部隊人員，並在他們的承諾和說服下，加入了海保部隊的少年隊。然而好景不常，曹常來在回到馬祖並在部隊開始新生活的幾年後，於1956年捲入部隊挾怨報復的事件中，而被以「抄寫匪書、參加叛亂組織」的罪名逮捕入獄，期間他遭受酷刑，最後被以叛亂罪判刑五年。不過曹常來命大，兩年後便無罪釋放回到家鄉。（詳細故事可參考劉宏文於馬祖資訊網的〈舅舅〉一文）

有些屬於那個時代的傷痛仍在延續。

林傳凱提到，雖然這些故事看似荒謬，但卻曾經是馬祖列島的日常。馬祖和本島有著非常不一樣的國家統治經驗，沒有經過清朝統治也沒有日本的殖民，而是在1940年代末期經歷劇烈的轉變，突然變成國共內戰的交界處。現代國家系統開始有意識地對日常進行掌控，甚至是深入島民的意識與身體，以至於對岸漂過來的一張垃圾都需要細細考察，這是臺灣本島人無法想像和對話的經驗。我們無從得知以漁業為生計的馬祖居民生活要如何繼續，出入列島捕魚都需要條子，海禁和宵禁讓捕魚窒礙難行；無法理解為何島民出入臺灣本島都受到極嚴格的管制，不論求學、探親、看病、移居都得經歷非常繁複且耗時的手續，彷彿馬祖島民隸屬另一個國度；無法體會原本的貿易和生活圈是如何被劃了一道明確的線，標示著自由中國（過往在臺國民黨政府的自稱）和大陸淪陷區，甚至作為忠誠及叛亂的分水嶺；更無法想像明明作為內戰前線的馬祖，為何有那麼多的人事物遭到忽略，無論是海保部隊不受國民政府待見，從事危險的情報工作卻只被當成臨時工，而無法領到情報局的退休金或得到任何照顧；抑或是島嶼的故事幾乎被臺灣史的書寫者所忽視。

如果臺灣史繼續以臺灣本島經驗作為書寫歷史的核心，那我們將會落入無可避免的線性敘事中，例如1895年只會是臺灣割讓、日治時代的開端，1947年是臺灣二二八事件，

1949 年是國民政府遷臺。那麼馬祖和其他島嶼的主體性，註定會隱沒在這些「理所當然」的時間分期，而無法展開新的敘事。也許我們無法輕易地認為臺灣的白色恐怖和馬祖的經驗能有對話，但確實有必要把這些島上發生的歷史重新納入臺灣史，甚至是在菁英為主的白色恐怖敘事中，納入更為多樣、有機的觀點。

《如果島嶼會作夢》雖無法將龐大的歷史納入其中，但透過不同藝術家的視角，將更多的身體性和感官體驗帶進相對封閉的島嶼，並在文字之外記錄下一些真正屬於馬祖的「聲音」與事物。

例如海風的呼嘯。
例如海浪在岩石懸崖邊的拍打聲。
例如島民們用自己語言吟唱和追悼。

In this talk, "A Look Back at Matsu: The Untold White Memories" local writer and historian Liu Hong-Wen was invited to talk with Assistant Professor Lin Chuan-Kai of Sun Yat-sen University of Social Sciences about the story of Matsu and the White Terror during the Martial Law era.

Professor Lin has been working in the field of the White Terror studies and on the localization of the historical township of Matsu, and when he compiled and returned the White Terror files about Matsu to the local community, the historical materials deeply shocked Liu. Even though it was a story he had been hearing since he was a child, the archives revealed a more specific and brutal past, a world different from that of gossip. This is why the lecture was introduced with the story of Liu's uncle, Tsao Chang-Lai (1936–2020), because in this man, who was forced into the current of the times, we can see an epitome of Matsu's modern history, and we can clearly understand that the archives are no longer just information, but a person's real encounters. However, within a Taiwan-centric historical narrative, it is difficult to see Matsu's position and local voices in modern Taiwanese history. Additionally, the public's negligence of Matsu's history has led to some public discussion of Matsu's White Terror history only in the last three years. Yet, when we read the history of Matsu more closely, we can actually notice that the burden of times falling on Matsu has in fact been even heavier than on Mainland Taiwan.

At the beginning of the lecture, Liu began by helping the audience sort out the history of Matsu before and after 1949 and how his uncle was involved in the story. Although

the Matsu Islands were an important fishing ground along the coast of the Qing Dynasty, they were an unstable frontier that was difficult for the empire to manage, and it was forbidden for a long time for any people to move there. It was not until the Republican era that people began to migrate to the Matsu Islands from eastern Min due to famine. Therefore, prior to 1949, Matsu basically shared the same social pattern and culture as the eastern Min region of the mainland of China, and even a common living sphere (including trade and fishing); yet it had little connection to Taiwan's society and a very different historical experience.

Tsao Chang-Lai's experience must be understood in this context. The story goes back to the 1950s, when the Kuomintang had long since retreated to Taiwan and the Matsu Chief Executive's Office had been established in Matsu as the front line, so it was logical to maintain hostile relations with the other side of the border. As a teenager, Tsao Chang-Lai was sent by his family to learn the craft of making fishing nets, a lucrative trade in eastern Fujian, and, of course, he and his master frequently traveled to and fro between the Matsu Islands and the other side of the border. However, when the group went to Fuzhou in 1950 to mend fishing nets, Tsao Chang-Lai was accidentally stranded on the other side of the border due to the outbreak of the Korean War, and while trying to return to his hometown in Matsu, he joined the First Maritime Security Column.

At that time, Matsu often traded with the other side of the Taiwan Strait, but because of the dangers along the coast, the guards would collect protection fees to ensure fishing and merchant vessels could safely enter and leave the Matsu Islands. This eventually led to the formation of an organized armed force. However, the Coast Guard was not a part of the formal military forces, but a local armed group, so it was not taken seriously by the national army for a long time. The CIA set up the Office of Policy Coordination (OPC) in Matsu in order to obtain more information on the Communists and used the Fuzhou- and Matsu-speaking Coast Guard to travel across the border to gather information. At that time, Tsao Chang-Lai met members of the Coast Guard who were gathering intelligence in Fuzhou, and with their commitment and persuasion, he joined the Junior Team of the Coast Guard. A few years after returning to Matsu and starting a new life in the army, Tsao was involved in an incident in 1956 due to vengeance in the army and was thus arrested and imprisoned on charges of 'copying bandit books and joining a rebel organization.' He was tortured and sentenced to five years for rebellion, but Tsao Chang-Lai was also lucky enough to be acquitted of all the charges two years later and sent back to his hometown.[1]

Even until now, some of the traumas of that era still linger.

Although these stories may seem absurd, they were once part of the daily life of the Matsu Islands, according to Lin Chuan-Kai. Matsu had a very different experience of national rule from the mainland, with no Qing Dynasty rule or Japanese colonization. It was only since 1949 that the modern state system began to consciously take control of everyday life, even into the consciousness and physical bodies of the islanders, to the point that a piece of garbage floating across the river required a detailed examination, an experience the main islanders of Taiwan could never imagine or dialogue with. We have no way of knowing how the residents of Matsu, whose livelihood is based on fishing, can continue to make a living; that they need a permit to enter and leave the islands for fishing; and how the sea ban and curfew make fishing difficult. We cannot understand why the islanders are subject to extremely strict controls when they enter and exit from Taiwan's main island; that they have to go through very complicated and lengthy procedures to study, visit relatives, seek medical care, and move to another country, as if the islanders of Matsu belonged to another country; and how the original trade and living spheres have been divided into different areas. It is impossible to understand how the original trade and living spheres were clearly marked as a line between free China and the fallen areas on the mainland, or even as a watershed between loyalty and rebellion[2]. It is also impossible to imagine why so many people and things were neglected in Matsu, a supposedly significant spot at the front line of the civil war, whether it was the fact that the Coast Guard was not treated well by the Kuomintang government; that the dangerous intelligence work was treated as temporary work, and that they were not able to receive a pension or any care from the Intelligence Bureau; or the story of the islands being virtually ignored by researchers of Taiwan's history.

If the history of Taiwan continues to be written based on the mainland Taiwanese experience, then we will fall into an inevitable linear narrative. For example, 1895 will only be the beginning of the cession of Taiwan and the era of Japanese rule, 1947 will be all about the February 28th Incident in Taiwan, and 1949 will still be the year the Kuomintang government moved to Taiwan. Then, the subjectivity of Matsu and the other islands is destined to be hidden in this 'natural' division of time, and no new narrative can be developed. It may not be easy to assume that there is a dialogue between the White Terror in Taiwan and the Matsu experience, but it is necessary to re-integrate the history of these islands into the history of Taiwan, even within the elite-dominated narrative of the White Terror, and to include a more diverse and organic perspective.

Although it is not possible to include the vast historical context of the island in *When Islands Dream*, still, through the perspectives of different artists, more physical and sensory experiences are brought into the relatively enclosed island, and the 'voices' and things that truly belong to Matsu are recorded beyond words.

Such as the whistling of the sea wind;
Such as the sound of the waves lapping against the rocky cliffs;
Such as the chanting and mourning of the islanders in their own language.

掃描 QR Code 觀看講座影片
Scan the QR Code to watch
the Talk

1 For more details, please refer to the article "Uncle" by Liu Hong-Wen on the matsu.idv.tw website.
2 "Free area of the Republic of China" , a term used by the ROC government to contrast itself with the People's Republic of China and avoid acknowledging their control over mainland China; often shortened to "Free China" and used in contrast to "Red China".

Sean Trudi Hsu
Wang Yu-Song

Yannick Dauby
Huang Hsiang-Yun

Emma Dusong

ARTISTS & WORKS

藝術家與作品

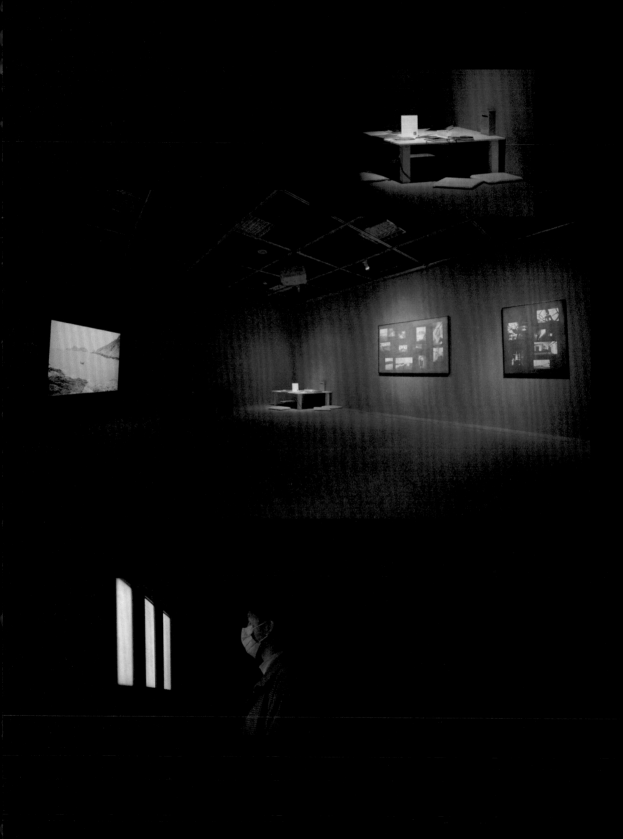

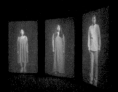

許生翰　Sean Trudi Hsu

舞踏手、身體工作者，臺南人。師事大野慶人。專長為舞踏、現代舞、戲劇及行為藝術，跨足編舞、表演、教學及顧問。個人作品常以舞踏純白的身體為基底，或以抑鬱、或以殘酷、或以痛苦為詮釋，透過不經遮掩的袒露與觀者進行碰觸，對深處的靈魂進行提問及批判。

Born and raised in Tainan, Sean Trudi Hsu is a Butoh dancer and a student of Kazuo Ohno. He specializes in Butoh, modern dance, theater, and performance art, and works across choreography, performance, teaching, and consulting. His works are often based on the pure white body of Butoh, interpreted in a depressing, brutal, or painful way, touching the viewer through uncovered exposure and soul-searching questions.

Photo by Huang Hsiang-Yun

〈島迴〉，單頻道錄像，10分29秒，2020。

Winding Islands, Revolving Dreams, Single-Channel Video, 10min. 29sec., 2020.

工作團隊→製作：謝宇婷　導演：許生翰　出演：許生翰、石泅瑄　拍攝：蔡宗勳、許博彥　剪輯：蔡宗勳
音樂：吳以琳　場地協力：刺鳥書店、七七據點　特別感謝：劉梅玉、曹以雄、曹楷智、邱意嫻
Crew List→Producer: Hsieh Yu-Ting　Director: Sean Trudi Hsu　Actors: Sean Trudi Hsu, Shih Ju-Hsuan　Cinematographer: TsaiTsung-Hsun, Hsu Po-Yen　Editor: Tsai Tsung-Hsun　Music: Wu Yi-Lin
Venue supported by Thornbird Bookstore, Fort No.77　Special thanks to Liu Mei-Yu, Tsao Yi-Hsung, Tsao Kai-Ji and Michelle Chiu

文｜許生翰

by Sean Trudi Hsu

來到馬祖，對我來說一切都從想像開始。寬闊的景，土地上恣意長著的綠，海在每個須臾躍升。這裡的人距離很近，就像我生長的故鄉一樣，好容易就能靠近，不像都市裡的人擁擠卻疏遠，炫目卻窒息的光折射在空氣當中，避都避不掉。

我並不曾在馬祖生活，更遑論經歷那些世代的創傷，我無法複製那樣的歷史，所以這裡的軍事建築或人們的政治傾向並不干擾我，在被海包圍著的小小陸地上，似乎可以暫時避免那種類型的談話，但時間久了或許就不一定。

馬祖的島很小，怎麼繞都能回到原本的地方。有許多圓環，必須遵從方向行進，以避免發生車禍。島也很陡，上上下下的，車道下面不知道是否藏著坑道，好像螞蟻的居所一樣。大概有這樣的感覺：像是被培養著的螞蟻窩，繞來繞去被看不見的玻璃給包圍著，出口被莫名的觀察者給堵住了，時不時地會餵養一些糖水。

在田野調查的過程中，我發現祈夢基本上就像臺灣島上的道教問事一樣，顯得沒有什麼特別，至少對我來說是如此。我不認識馬祖島上的神明，因為有點陌生，大致上相敬如賓，也各無所求。這段日子當中，裝進身體的並不是各種名勝景點或文物館中的說明文字，而是最直接而真切的體感，一種幽微細膩的悶。我們不斷地在島上行走，使我憶起舞踏藝術家大野慶人（Yoshito Ohno）對於行走本質的教誨，於是打開了手掌上的眼睛去探索、踩著腳底的眼睛去觀看這些路程。

島嶼並不是監所，卻像有遊魂籠罩著一般，在晴朗的白天裡還是有種看不見方向的感覺，某種在知覺之外的陰鬱因為不斷重複經過相同的分叉路及圓環而積累，但夢的界線因為手與腳的眼而被打開了。這一段沒有結尾的儀式循環反覆，完整了圓也陷入無盡的憂傷——如果我出生在這裡，絕對會有強烈的、無法被阻止的慾望，想要去破除什麼。我猜那是因為我們在繞圈，不斷兜圈子這樣的重複動作讓我想要試試看不同的路徑，那是一種即便徒勞無功也想要穿越的感受。

坑道裡面充滿遊魂，不是字面上的鬼，而是記憶的再現。每個走過坑道的人與事都被周圍的石頭與水泥給記錄下來，因為窄小而被壓縮，這種感覺在看見射擊台那樣的破口時候地開展，鬱悶的感受像子彈一般往海奔騰、解放。我對這些島嶼的體驗集結在坑道的路徑裡，坡度依然陡峭，有時候近乎迷失方向。

在這部影像作品中，閉上雙眼的純白身體成為容器，裝進身處馬祖的抑鬱感受，環繞在島的各處，不斷遊走、交替及錯置，夢遊似地被標誌在馬祖的地景當中，以非人之姿進行遊蕩，走過坑道、老房、海石與道路。海浪繞著馬祖周圍的尖刺，再次將夢遊者推回坑道當中，周而復始。白身蒐集凝結著思緒，如同柔軟而脆弱的絲線一樣，逐漸將我對島嶼的想像纏繞。

閉上雙眼，讓身體進入似睡非睡的狀態。在一種試圖睡著的時刻，讓夢遊者的肉身睡去，精神卻還得行動，遊走在清醒與夢交接的境地。身體對這個失去意識的接縫感覺到不安，呈現出如同動物一般的質感。失去視覺後所有感官張望四周，確定每一個步伐及每一個時刻周遭是安全的，意識逐漸卸下警戒，恣意以那純淨而脆弱、敏感的肉身感受島嶼上的一切。

在馬祖的所有感受在這條路徑當中集結起來，投射到夢遊者的行走當中，激起擺盪，交換後再回歸，像是海面上被激起的白色泡沫，就那樣地生滅著。不斷持續；又如同故障的放映機，播放著一張張投影片，在特定的時候從頭開始。浮現、經歷，然後消散，夢被時間串聯成未經編碼的程式，意識在其中遊走、錯置，與未知的夢境交換、重疊，是誰入侵了這條路徑？

遊魂沒有醒來，這場行走的儀式、沒有肉身的代言，依舊在持續著。我希望透過這場迷惑的行走，召喚觀者來到馬祖，沒有預設地讓自由的意識遊蕩在島嶼上。

When I came to Matsu, for me, everything seemed to just be starting from my imagination. The vast landscape, the greenery growing freely on the land, and the sea leaping up at every moment. The bond of the people here is tight, just like that in my hometown, so for me, it is easy to get close to this place. It is different from cities where there are large crowds, but people are distant from each other; there, dazzling but suffocating light is reflected in the air, and no one can escape.

I have never lived in Matsu, let alone being through the traumatic experience those generations had back in the days, and I can't replicate that kind of history. Thus, I don't feel bothered by the military architecture or people's political leanings here, and on a small land mass surrounded by the sea, it seems like that kind of talk can be avoided for a while, but maybe not after a while.

Even the largest island of Matsu is so small that no matter where one goes, they are

always able to return to the original location. There are many roundabouts, and one must follow the directions to avoid accidents. The island is also very steep, with a lot of ups and downs; I wonder if there are potholes underneath the driveways, for it seems like a formicary to me —surrounded by invisible glass with its exit blocked by an unexplainable observer who would feed the ants on some sugar water from time to time.

In the course of my fieldwork, I found that Dreaming Ceremony was basically similar to querying a Taoist priest on the island of Taiwan; it was nothing special, at least to me. I did not know the gods on the Matsu Islands; as they were somewhat unfamiliar to me, I just showed general respect for them without posing any request on them. During these days, what was packed into my body was not the explanatory texts at the various scenic spots or in the heritage museums, but rather the most direct and genuine physical sensation, a kind of subtle and delicate boredom. As we kept walking on the largest island, I recalled the teaching of Yoshito Ono on the nature of walking, and thus I opened my eyes on the palms of my hands to explore, as well as my eyes on the soles of my feet to see the journey.

The island is not a prison, but it seems to be shrouded by wandering spirits, and there is a feeling of not being able to see directions even in the clear daylight. And a gloomy feel is accumulated through the constant and repetitive passing through the exact same intersections and roundabouts; yet the border of dream is on the other hand broken through by the eyes on the palms and the soles. This endless ritual circulates and repeats itself over and over, but while the process completes some sort of circle, it also sets itself up in endless sadness. If I had been born here, I would definitely have a strong, unstoppable desire to break something. I guess it's because we are circling; it's this repetitive action of going in circles that makes me want to try to see a different path —it's a feeling that "even if it's in vain, I still want to cross".

The tunnel is full of wandering spirits —not ghosts in the literal sense, but the recurrence of memories. Every person and event that walked through the passage has been documented by the surrounding rocks and concrete, compressed because of the small size, and this feeling would abruptly burst and sprawl whenever I saw a breach like a shooting platform, while the sense of depression would resemble a bullet rushing towards the sea and liberated. My experience with these islands was concentrated on the paths of the pits, which are still steep and sometimes seems as if they were almost lost even to this date.

In this video work, the white bodies with the eyes closed become containers for the depressing feelings of being in Matsu, wandering around the island, alternating and staggering, dreamily marked by the Matsu landscape, wandering in an inhuman manner, walking through the tunnels, old houses, rocks and roads, the waves surrounding Matsu with spikes pushing the sleepwalkers back into the tunnels again, and so on. The thoughts condensed in my white bodies were like soft, fragile threads that gradually entangled my imagination about the island.

I closed my eyes and let my body enter a quasi-asleep state, making the sleepwalkers' physical bodies asleep while the spirit was still on the move, wandering in the realm where dreams meet. The bodies felt uneasy about the unconsciousness of the seam while showing the texture of an animal. As the sleepwalkers lose the sense of sight, they open up all senses to 'look' around to make sure that every step and every moment was safe. Meanwhile, their consciousness gradually became unguarded and was able to feel everything on the island with their pure, fragile, sensitive bodies.

All the feelings in Matsu are gathered together on this path and projected onto the walk of the sleepwalkers, stirring up oscillations, exchanging sentiments and then returning, like white bubbles stirred up on the surface of the sea, emerging and disappearing. It is like a faulty projector, playing back the slide film piece by piece and restarting at some specific point. The dream is strung together by time into an uncoded program in which the consciousness wanders, being misplaced while exchanging and overlapping with the unknown dream. Who is it that intrudes this path exactly?

The wandering spirit has yet to wake up. The ritual of walking continues without the endorsement of the physical body. Through this mystifying walk, I wish to call the viewer to come to Matsu and let their free consciousness wander around the island without expectations.

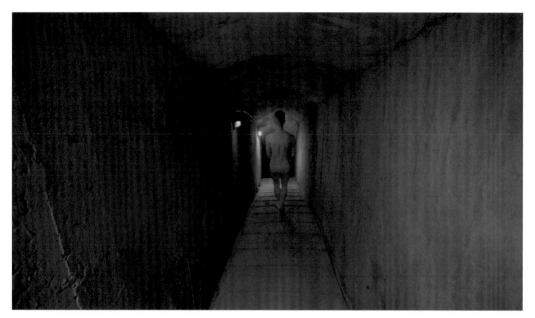

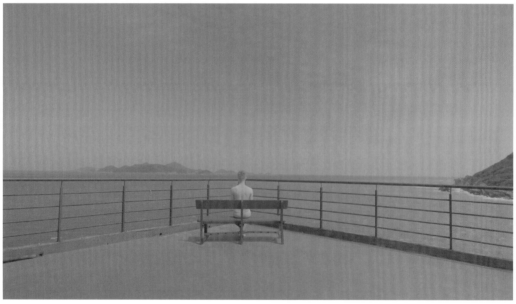

Screenshot of *Winding Islands, Evolving Dreams*

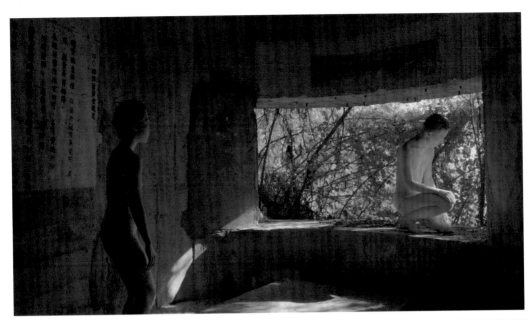

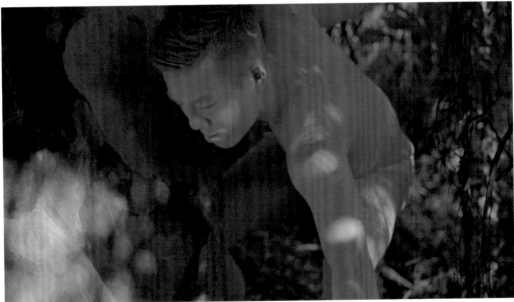

Screenshot of *Winding Islands, Evolving Dreams*

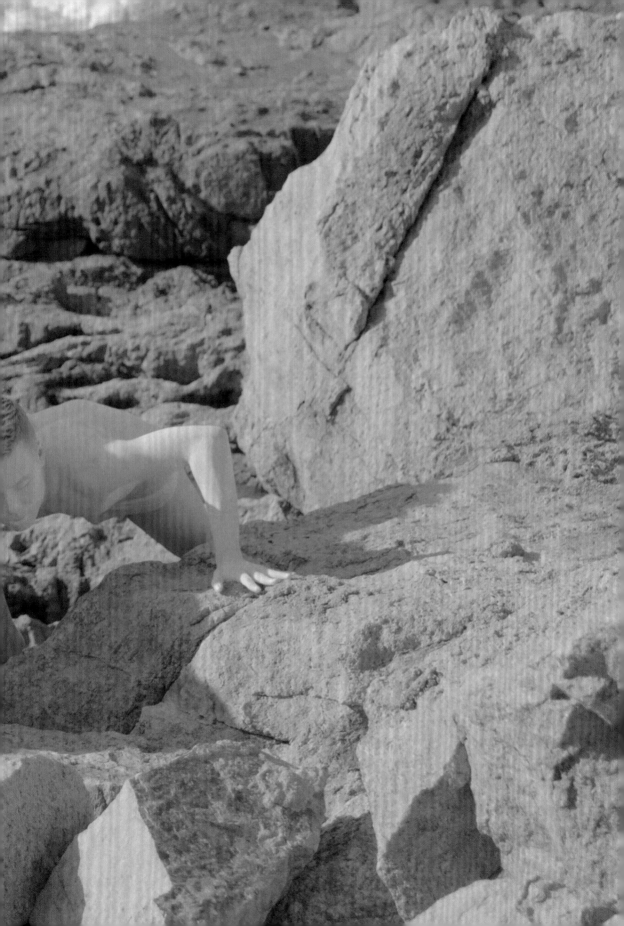

王煜松　Wang Yu-Song

sean0978622068.weebly.com

王煜松的作品以複合媒材為主，透過自身的生命經驗及個人觀察，在生活中探索各種創作的可能。大學時期的作品，以思考繪畫及版畫本身的媒材為出發，但運用不同於繪畫及版畫的方式去接近關於其本質的事物，作品經常融入身體感知，空間場域……等等元素。

近期的作品關注於空間中曾經存在的過去，正在發生的現在，以及可能發生的未來。透過各種想像拼湊再閱讀，從自身的生活環境、生命經驗擴及到更廣的社會意識、群體關係，試圖探尋虛構及真實之間的曖昧地帶。透過物件，影像，或空間本身，將觀者帶入類似於故事性的場域，使觀者透過各種感官進入其中，自行閱讀及想像。

Born in Hualien in 1994, Wang Yu-Song is currently a student at the Graduate Institute of Plastic Arts, Tainan National University of the Arts, Taiwan. He received a B.A. in printmaking from the School of Fine Arts, Taipei National University of the Arts in 2016, and graduated from Hualien Senior High School in 2012. A mixed-media artist, he aims at exploring various possibilities of creation in everyday lives through lived experience and personal observations. During his college years, Wang was devoted to pondering the respective medium specificity of painting and printmaking, and at the same time attempted to come close to the essence of things with artistic practices other than these two mediums. His works often incorporate affects, physical sensations, and spatial elements. His recent works focus on the "past" that has existed, the "now" that is happening, and the "future" that may take place. Wang likes to explore the ambiguous zone between fiction and reality through his own living environment, lived experience, and to a greater extent, social consciousness and relationships in groups. Through objects, images or particular spatial configurations, his works invite the viewers to open up all their senses and read and interpret the works with their own imagination.

Photo by Hsu Po-Yen

〈在燈塔的日子I〉，水彩紙、鐵氰化鉀、檸檬酸鐵銨，157×108公分，2021。
Days in the Lighthouse I, Watercolor paper, Potassium ferricyanide, Ferric ammonium citrate, 157×108 cm, 2021.

在燈塔的日子──訪談王煜松
Days in the Lighthouse: Interview with Wang Yu-Song

訪談、整理：謝宇婷

Interviewed and compiled by Hsieh Yu-Ting

謝宇婷（以下簡稱問）　你一開始是怎麼知道東莒燈塔的駐村計畫的？

王煜松（以下簡稱答）　我是在網路上看到的，它寫說這是臺灣第一個開放讓藝術家進駐燈塔的活動，是交通部航港局舉辦的。最終目的是希望帶動當地的觀光。我很想要瞭解燈塔裡面的人是怎麼生活的，因為在我創作〈花蓮白燈塔〉這件作品的時候，其實連燈塔都沒有進去過，一般人也很難有機會進去。

問　可以談談駐村的經歷嗎？

答　這是我第一次駐村，先前對於駐村是透過想像來建立，沒有實際經驗。

在此之前我也從來沒去過馬祖，連它的地理位置都沒概念。我要出發的時候，因為起大霧飛機停飛，臨時改成搭船去，晚上從基隆出發，隔天早上到南竿。我那時候覺得最有感覺的是在船上的那個夜晚，雖然躺在床上很安穩，但你就會感到自己的身體不斷地在移動，是個蠻特別的開場。在進入一個不曾去過的地方時，要經歷一個這樣的過程，就像夢境的開頭。也像是剛從媽媽肚子裡出來，第一次離開液態的羊水，認識到這個新世界的感覺。而且搭船的時候手機完全沒有訊號，所以根本沒辦法透過手機去連結這個世界。晚上在海上只有船會發光，那天沒有月亮，可以看到天上的星星還有海的波紋。

駐村一開始我住在燈塔旁的某個房間（過去是倉庫），沒有冷氣，蚊子超級多。一開始還可以忍受，然後到第二天、第三天開始受不了，我還因此做了一張藍曬圖，就是到底打死多少隻蚊子，很像星空，蠻好笑的。後來燈塔主任看不下去，於是我就改住到有冷氣的辦公室，睡沙發，狀況就好多了。

問　為什麼會想用藍曬圖創作？

答　我以前有畫過一張〈花蓮白燈塔〉的設計圖，想像它過去的樣貌，原初計畫是想要透過實際的駐村，去想像過去，畫一些關於過去的設計圖，相對於一般設計圖是預想未來，我想也許以預想的角度找尋過去，會發現更多可能。而選擇藍曬圖作為媒材，是因為早期設計圖都是以藍曬的方式呈現，也是我們俗稱的藍圖，意指對未來的想像。

我不想要預設太多，所以就只是帶一個技術跟初步的概念去。

然而到了當地，我反而更想捕捉駐村的當下。因此，我透過藍曬的技術將駐村當時的光捕捉下來。思考光在這個空間裡的存在，關於過去、未來、現在、時間與空間、記憶與想像；光是一種既抽象又真實的物質。這些藍曬就像是當時所留下來的日記。

透過藍曬這個技術也可以跟當地人交流。我後來在當地的成果展辦在燈塔的文物室，選在晚上六點開展，故意不開燈，讓觀眾帶著手電筒來，透過光影重新認識燈塔園區，手電筒投影在燈塔的白牆上，就很像每個人都帶了一座燈塔的感覺。

問　如今回想起在馬祖的時光，你有什麼感覺？

答　我覺得我只是過客，很難有明確的立場。但在馬祖的感受很深刻，時時看到海，會很強烈地意識到自己在島嶼上，雖然臺灣也是海島，但是因為尺度的差異而沒這麼強烈的感受，比較不會有隨時身在島嶼上的感覺。馬祖也介於臺灣跟中國之間，就像是模型的對照，臺灣之於中國，如同馬祖之於臺灣，但是當然彼此的關係又不同，彼此獨立但又曖昧的感覺其實相當複雜。我在島上的日子很像在作夢，好像是片刻的抽樣，與在台灣的生活類似而又相異。

我沒有選擇去碰觸所謂的戰地遺跡或政治，一方面是因為我覺得太沉重了，不知道怎麼跟它對話。它太過巨大，就算去講，好像也是多餘的，那種感覺到當地就可以很直觀地感受到，我選擇在那裡生活，記錄我的感受，也許自然而然會有想法。我也不覺得我一定要帶給當地什麼觀念，這裡有屬於這裡的樣貌。

1 How did you first learn about the residency program at the Dongju Lighthouse?

I saw it on the Internet, and it said it was the first program to open up the lighthouse to artists, organized by the Bureau of Shipping and Harbor of the Ministry of Transportation. Ultimately, the goal of the program is to promote local tourism. At that time, I was eager to know how people lived and worked inside a lighthouse. When I created the work *Hualien White Lighthouse*, I didn't have the chance to be in the lighthouse, which is in fact not fully available for people to go inside.

2 Can you tell us about the experience of your residency?

This is my first ever artist residency, so I had no actual experience to help me imagine what it would be like from the first place. I had never been to Matsu before, and I didn't even know where it was located. When I was about to go, the plane was canceled because of fog, so I took a boat instead, leaving Keelung at night and arriving in Nangan the next morning. I felt that the most intriguing part was the

night on the boat. Although lying on the bed seemed to be peaceful, on the boat, you would actually feel your body constantly moving. It was pretty special to start my residency this way. When you enter a place you have never been, you have to go through a process like this, just like the beginning of a dream. It is similar to how a baby comes out of his or her mother's belly, leaving the amniotic fluid and entering the new world. On the boat, there was also no cellphone signal at all, so you simply could not connect to the world through your phone. At night on the sea, only the boat would glow, and that day, the moon was not out, so I could see the stars in the sky and the ripples of the sea.

I started off living in the room which was originally the lighthouse warehouse, with no air conditioning but mosquitoes everywhere. At first, I could still tolerate it, but on the second and third days, I could not stand it anymore. I made a cyanotype to show how many mosquitoes I killed. It looked very much like the starry sky, and it was quite funny. Later, the director of the lighthouse couldn't bear seeing me suffer anymore, so I was able to move into an air-conditioned office, which was so much better.

3　How did you start creating with cyanotype?

My original plan was to imagine the past through the residency, and to draw some design layouts about the past. I chose cyanotype as the medium because design layouts of early days were presented in the form of cyanotype, which is also commonly known as 'blueprint,' an imagination of the future. I didn't want to presume too much, so I only brought a preliminary technique and concept with me.

However, after I arrived, I ended up wanting to capture the present moment of the residency more. Therefore, I captured the light during the residency through the technique of cyanotype. I thought about the existence of light in this space, about its past, future and present, time and space, memory and imagination; light is a kind of abstract and physical substance simultaneously. These cyanotypes are like a diary of the time left behind.

Through the technique of blueprint, I was also able to interact with the local. I presented my works in the exhibition room of the lighthouse at 6:00 p.m. I deliberately turned the lights off so that the audience had to bring flashlights and reacquaint themselves with the lighthouse through light and shadow different from daylight, and the flashlights were projected on the white walls of the lighthouse, as if everyone had been carrying a lighthouse with them.

4　What do you feel when you think back to your time in Matsu?

I think I was just a passenger, so it's hard to have a clear position. However, I had a

very strong feeling when I was in Matsu. When I saw the sea, I was highly aware that I was on an island. Although Taiwan is also an island, I have never felt so strongly about this fact due to the difference in scale. Matsu is located between Taiwan and China, so it's like a model comparison—Taiwan to China is as Matsu to Taiwan—but of course, their relationships are different. It is complicated how the islands are independent from and interdependent with each other at the same time. So, my time on the island was very much like a dream, like a momentary sampling, similar to but different from my life in Taiwan.

I didn't choose to approach those elements known as war relics or politics partly because I felt it was too heavy, and I didn't know how to have a conversation with it. It was so huge that it seemed superfluous for me to talk about it. I chose to live there and record my feelings, and I don't feel that I have to bring any concept to the place. Matsu has its own perspectives and behavioral patterns after all.

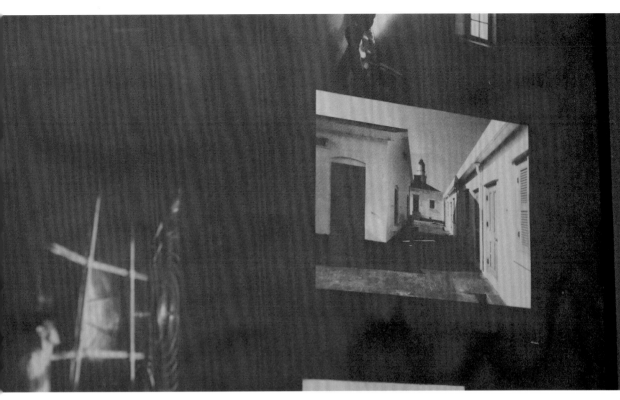

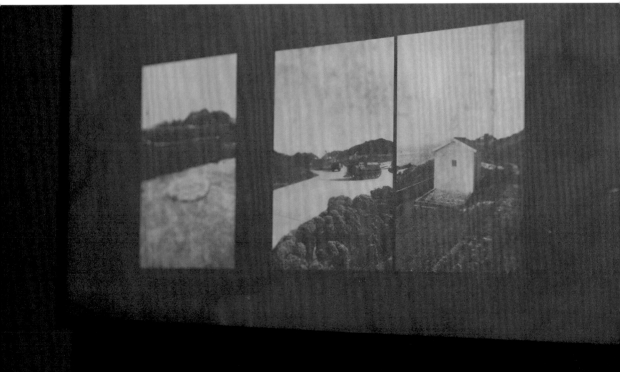

Photo by Hsu Po-Yen

澎葉生　Yannick Dauby　　　　　　　　　　　　　　www.kalerne.net

1974 年生於法國，他的專業養成為具象音樂和即興音樂，使用拾得物、電子原音工具和攝音術。

作為一個錄音工作者，他對於動物、自然聲音和都會／工業情境，以及不尋常的聲音現象，都很感興趣。他也與音樂或舞蹈工作者、視覺或影像創作者時常合作，生產出的形式如影音演出、出版或裝置、展覽。他同時也是獨立電影領域的聲音設計與混音工作者。

2007 年起，他主要生活與創作地點在台灣。著迷於人類學與生態學的他，透過個人創作與研究，持續探索這座島嶼的聲音風景，發展與地方社群有關的創作計劃、紀錄某些環境內的生物與環境的互動。他也與生物學家合作，創造介於藝術與地方的計畫。近期出版山林環境錄音書〈福山，太平山〉。（中英雙語）

b. 1974, France/Taiwan. Background in musique concrète and improvisation, using found objects, electroacoustic devices and phonographies.

As a sound recordist, he has particular interest for animals or nature sounds as well as urban/industrial situations and unusual acoustic phenomena. Excursions are pretext to a sonic gathering, and often leads to the realization of phonographic collages. He often collaborates with other musicians, visual artists and dancers, producing audio-visual performances, publications or installations. He is also an independent and awarded sound designer and sound mixer for cinema: documentary films, short films, fiction and experimental cinema.

He has based in Taiwan since 2007, interested into the field of anthropology and ecology, exploring the island's soundscape through artistic research, developing art projects in local communities (Hakka, Atayal) and documenting the fauna and its environment, creating art & science projects in collaborations with biologists. He has been involved in projects related to coral reefs in Penghu and mountain forests in Northern Taiwan.

Photo Credit: Museum of Contemporary Arts Taipei

〈在馬祖，她一無所聞。她聽聞一切。〉，單頻道錄像，31分57 秒，2021年5月於馬祖田野踏查，2021年6月至10月剪輯。

She heard nothing in Matsu. She heard everything. Single-Channel Video, 31min 57sec, Field work in Matsu in May 2021; Editing from June to October 2021.

在馬祖，她一無所聞。她聽聞一切。──訪談澎葉生
She Heard Nothing in Matsu. She Heard Everything: Interview with Yannick Dauby

訪談、整理：謝宇婷

Interviewed and compiled by Hsieh Yu-Ting

謝宇婷（以下簡稱問） 與你以前在澎湖、綠島等島嶼的錄音和工作經驗相比，馬祖給你什麼樣的感覺或想法？

澎葉生（以下簡稱答） 我在澎湖群島的活動比較特別：我從 2004 年開始定期訪問，並在那裡待了相當長的時間，任何與澎湖有關的作品都是我長期積累的結果。而綠島則相反，我只為了一個聯展去過幾次，時間很短也很緊湊。對我來說，能夠重複回到同一個場域並持續在那裡工作，是很好的機會：作為一個藝術家，我不喜歡只是單純當個訪客，或者更糟的是當一個觀光客。錄音對我來說是紮根於一個空間的方式，它並非通過技術過程獲得材料，而是體驗一個地點，並記錄聽覺體驗。這也是我想加入《如果島嶼會作夢》計畫，再次拜訪馬祖的原因。

馬祖列島最令人印象深刻的，肯定是島與海的不尋常關係。由於島嶼周圍的懸崖和軍事設施，可以感受到島民對大海的距離感。即便海洋以藍灰的色調、飄浮的雲朵與波光粼粼的水面包覆島嶼，但人們往往很難親近大海。而當人們到達岸邊時，也往往有點危險，岩石上佈滿了破碎的玻璃，有時還有劇烈的海浪。從過去持續至今的兩岸對峙局勢、僅僅在 30 年前才結束的戒嚴，以及當地人講述的故事，都與這樣的印象共同建構出非常獨特和緊張的海洋環境。

問 你是如何構思這件作品的？你的作品如何回應展覽主題？

答 我大部分的創作過程使用了法文所說的「拼裝」（Bricolage）概念。李維史陀（Claude Lévi-Strauss）在他開創性的著作《野性的思維》（La pensée sauvage）[1] 中描述了這種借用與回收概念、想法或神話的方式。這與建築師的工作方式截然不同，建築師首先繪製建築、製作工程圖，然後由建築工人來建造。「拼裝者」（Bricoleur）則收集東西，再透過漸進和持續的過程把它們組裝起來。

我最初沒有想到這件錄像作品的時間會這麼長，作品的時長取決於我收集到的素材，而我難以割捨其中一些迷人的成分。我大多數的個人創作，總是等待完成田野工作後再決定作品的形式。田野材料本身會引領、告知我可能的創作內容。

在這件作品中，對於聲音的記錄，我使用了我常用的高規格設備（是我使用了十幾年

的設備），獲得的結果一如預期。但對於圖像，我想放一些過時的東西，具有檔案文件的質地，有一種夢境般的質感。這就是為什麼我使用我心愛的1970年代小台旁軸測距相機，並使用柯達製作的電影底片，它能呈現非常特殊的顏色，稍微曝光過度和褪色，有點超越時間的感覺。

而最大的驚喜，是我在現場發現與聲音技術有關的珍貴軼事和物件。這些意想不到的元素與馬祖的特殊文化和歷史背景有關，很容易與聲音和影像素材相結合。

從採訪到故事編輯、到地景的聲音影像體驗，整個過程提出了一連串相當不確定的訊息和感覺。觀看整部作品或其中的片段後，觀眾會產生一種對島嶼的模糊印象，而不是看到宣言或敘述──就如同醒來後試圖記住一個夢。

問　你是如何為這部作品進行實地調查的？有發生什麼有趣或難忘的事情嗎？你如何收集轟炸的聲音和其他特殊的聲音？

答　在實踐層面上，田野調查十分不容易。由於我在台北還有工作，時間安排非常緊湊。幸運的是，在採訪過程中，如果我錯過一些要點，我太太蔡宛璇會幫助我。調查期間，我們不得不帶著兩個孩子。我們搭乘了飛機跟船，但主要是騎摩托車在島上移動，還遇到了相當糟糕的天氣，卻也因此經歷了一些有趣和史詩般的時刻。在採訪間的空暇，只要雨況和孩子們允許，我有時會停下來做一些錄音或拍攝，但一切都得在緊急情況下完成。我經常把我的設備藏在寺廟前的滑板車上一整晚，以便在清晨時錄製誦經聲，或者讓它們在森林裡放過夜，希望得到一些鳥鳴聲──到了早晨，我的設備往往被雨淋濕。

受訪者多半是透過你或朋友認識的，大部分是在馬祖生活和工作的年輕人，只有一半是馬祖人。我的提問和受訪者選擇是非常主觀的，因為這項工作絕對不是民族誌調查，但同時我很小心地去注意創作過程如何展開。它更接近於「漂移」（Dérive）和精神地理學（Psychogeography）的經驗，漂移在遐想的時刻和直接接觸這個地方的現實之間，而不是一部關於馬祖列島的紀錄片。

野外錄音工作需要做好準備，並迅速地進行即興創作。設置一個聲音陷阱（讓錄音設備運轉12小時，期間我並不在現場）需要預測，但當我在戶外時，一旦聽到什麼聲音，也要有能力立即做出反應並把它們記錄下來。我就是這樣記錄到砲擊聲響的：在東莒的一條小路上，我早早地準備好了設備，砲擊聲只出現幾次，而我像收集莓果一樣收集它。

問　錄音是通過人工媒介捕捉聲音。你在2015年的MAD講座中，將你的工作描述為「將介面放在事物之間」。你能就此進一步說明嗎？這是否也是你對藝術創作的描述？

答　錄製聲音是創造一個可以重複分享的聽覺情境。「捕捉聲音」的說法有點危險，因為錄

音的位置、手勢、記錄者的習慣和工具本身，確實對被記錄的材料有很大影響。野外錄音師的作品，是以特定的聲音空間內發生的聲音事件為基礎，混合了自己通過麥克風（對我們來說不是人工的東西，而是我們感知過程的延伸）的聽覺體驗，以及在錄音過程中和稍後在錄音室裡一系列有意的決定（選擇要分享的片段以及如何處理材料）創造而成。

換句話說，我並沒有真正收集孤立的聲音，而是在一個有許多聲音發生的地方，生產一些事後可以聆聽東西，使人能夠與那一刻產生連結——這包括風在我麥克風上的產生的雜音、房間的回音、構成背景的各種不同微小聲音，或海浪或城市的竊竊私語。

就像人類學家提姆英格德（Tim Ingold）說的，我們其實不是在聆聽聲音，而是藉由聲音來聆聽——有點像我們不是注視光本身，而是透過光看見事物。[2]

問　在這件作品中，你為什麼選擇混合不同的材料（聲音、採訪、照片、文字），來組成多層次的敘述？

答　我主要想收集馬祖的聲音和居民對這些聲音的描述。錄音的過程當然需要四處走動、拜會人，對我來說，記錄在田野工作中遇到的軼事和故事是非常自然的，攝影則比較含糊，我經常需要以此記錄我到訪之處，幫助我記住錄音的地點和情況，甚至有時會藉此取得一些地點的 GPS 坐標。另外，我確實喜歡使用底片或數位相機創作影像，最近幾年，我很大一部分非創作性和非個人的工作是處理電影的混音與聲音設計。2021年起，我開始進一步發揮攝影和聲音的組合，將它們組裝成短片。這些不同材料的交織非常令人興奮，不僅對創作者而言，對觀眾也是如此：通過相當鬆散和模塊化的蒙太奇，人們可以收集每個聲音、圖像和文字片段所提出的意義，並找出它們之間的關係。即使影片節奏並不慢，觀眾仍可以透過聆聽的時刻，消化影片中不同的元素。

當然，我一直受到傳奇電影創作者克里斯・馬克（Chris Marker）的影響，也想向他致敬。他的傑作《堤》（La Jetée）[3] 和《如果我有四頭駱駝》（Si j'avais quatre dromadaires）[4] 以幻燈片的形式呈現，啟發了我這件作品。還有電影民族學家尚・胡許（Jean Rouch），他早期的電影透過聲音與影像，建構出一種迷人的不連續性。

問　這不是你第一次訪問馬祖，也不是你第一次創作關於馬祖的作品。你如何看待這件作品與其他馬祖相關作品的關係？

答　這是一個美好的巧合，我同時在準備兩個展覽。一個是你為台北當代藝術館策劃的《如果島嶼會作夢》，另一個是由陳宣誠和廖億美為馬祖國際藝術島策劃的展覽《傾聽島嶼的聲音》。為了這次在馬祖的展覽，我在 2020 年進行了第一次田野工作，重點放在調查廢墟和廢棄軍事據點的地下聲音。我在那裡花了幾天時間，記錄坑道的共鳴和房間的音調，並將它們與稀疏的文字和圖像組合起來，形成了我針對馬祖第一件基於

環繞聲響的創作，名為〈一座遠離海洋的島嶼〉，並在2021年台灣國際紀錄片影展上放映。

然後我同時準備了錄像〈在馬祖，她一無所聞。她聽聞一切。〉和馬祖國際藝術島的展覽。後面這件作品〈駐波〉完全沒有圖像、文本或現場錄音：它是一個聲音裝置，由限定於一個地點的聲音和現成物組成，也就是在南竿53據點的建築。

所以這兩件作品是非常互補的。這部錄像用中介經驗的片段製作，通過聲音與影像敘述呈現給台灣和國外的觀眾，另一個展覽只存在於53據點這個特定的建築中，進入軍事建築的觀眾利用視覺和聽覺，在現有的環境中感知藝術品，是一種物理性的體驗。

1 Compared to your previous recording and working experience, including on islands like Penghu and Green Island, what kind of feelings or thoughts does Matsu give you?

There is something very specific with my activities in the Penghu archipelago: I visit those islands regularly since 2004 and have spent quite some time there in total. Any work that I have created in relation to this place is the result of a long process of experience and interaction. In comparison, with Green Island, I only visited the place a couple of times and each for a very short and intense period of time to participate in a group exhibition.

It is quite a chance to go back and continue to work in the same location. As an artist, I dislike the feeling of being a simple visitor, or worse, a tourist. Sound recording is for me a way of rooting in a space. It's not just about getting some material through a technical process, but more about experiencing a location and documenting this listening experience. It is also why I am interested in joining this project and revisiting the Matsu islands.

The most impressive feature of the islands of Matsu is for sure its unusual relation with the sea. Because of the cliffs all around the islands and the military installations, one can really feel the impression of distance that islanders may have for the sea. The marine landscape wraps the islands with its blue, green and grey colors, with moving clouds and reflections of the sun on the water, but it is often difficult to physically get close to the sea. And when one reaches the shore, oftentimes, it's a bit dangerous as some rocks were intentionally covered with shattered glasses and sometimes struck by violent waves. When we connect this impression to the past and present threats by the neighboring country, to the martial law in Taiwan that ended only three decades ago, and to all the stories that can be heard from local people, it makes this place a very unique and rather stressful marine environment.

2 How did you come up with the idea of the work? How does your work respond to the theme of the exhibition?

Most of my creation process can be described as what we call in French "Bricolage." Claude Lévi-Strauss once described this way of borrowing and recycling concepts, ideas or myths in his seminal book *La pensée sauvage*[1]. It's a very different method than an architect's work, for example, who draws a building, makes the map and then has it built by construction workers. The "Bricoleur" gather things, assembling them progressively and continuously.

I originally didn't expect such a long piece. The duration, but also the nature of this artwork was determined by the materials I gathered: I couldn't resign myself to ignore some of these fascinating components. For personal creation, I always wait until I finish the field work before deciding the form of an artwork. The field material itself will guide and inform me of what I may create.

In this project, for sound recording, I used my regular high-quality equipment (the same one I have been using since a dozen of years ago) for a very predictable result. But for images, I wanted to have something anachronic, with the texture of an archival document and a dream-like quality. This is why I took my beloved tiny range-finder camera from the 1970s and used a film made by Kodak for cinema, providing this very special color, slightly overexposed and faded.

The greatest surprise is about the precious anecdotes and real objects I found in the field which were related to audio technology. These unexpected elements were connected to the special cultural and historical context of Matsu and could be easily combined with audio-visual materials.

The whole process, from interviews to the editing of the stories and the audio-visual experiences of the landscape, proposed a quite uncertain flow of information and sensation. After you watch the whole piece, or an extract of it, it will bring you more of an impression, a blurred picture of the islands, rather than a statement or a narration —not very different than waking up and trying to remember a dream.

3 How did you conduct the fieldwork for this work? Did anything interesting or memorable happen? How did you collect sounds of bombing or other particular sounds?

At a practical level, the fieldwork was quite an adventure. The time schedule was extremely tight because of my work in Taipei. Fortunately, Wan-Shuen Tsai helped me during the interview if I missed a few points during the interviews, but we had to bring two children along during our stay. We took planes, boats but mostly drove motorcycles, and we got quite bad weather and, as a consequence, some funny and epic moments! So, in between interviews, I stopped sometimes, when the rain and

the children allowed me to do some recordings or some photos, but everything was done with a feeling of emergency. I often left my equipment overnight, hidden on a scooter in front of a temple for getting some early chanting, or in a forest hoping to get some birdsongs—but in the morning I would find my gear soaked by the rain.

The interviewees—we met them all thanks to your contacts or friends—are mostly young people, living and working in Matsu, but only half of them are originally from there. My questions and the choice of these people are highly subjective. This work is definitely not an ethnographic survey, but I was careful to stay aware of how this creative process deployed itself. It is rather closer to an experience about Dérive and Psychogeography rather than a documentary about the islands of Matsu, drifting between moments of reverie and tapping into direct contact of the reality of the place.

Field recording work also requires me to get prepared and improvise very quickly. Setting up a sound trap (leaving the equipment to record during the 12 hours when I am not physically present) means to anticipate something. But as soon as something is heard when I am outdoor, I should be able to react instantaneously and record it. That's how I could record the cannon shooting exercise: during an early walk on a path in Dongju with my equipment ready, the bombing sound just took place a few times, and I simply collected it like one would gather berries.

4 Recording is capturing sounds through an artificial medium. And you described your work as "putting an interface between things" in your MAD 2015 lecture. Could you elaborate more on this artistic approach?

Recording sounds is creating a listening context that can be shared repetitively. The idea of "capturing sound" is risky because positions, gestures, habits of the recordists and the tools themselves do have a strong effect on the recorded material. Field recordists create a hybrid combining their own listening experience through those microphones (something that isn't artificial to us, but a kind of extension of our perception processes) with a series of intentional decisions made in the recording context and later in the studio (selection of fragments to be shared, sometimes manipulation of the material), based on the acoustic events that occur inside a specific sonorous space.

To say it in another way, I do not really collect isolated sounds, but inside a space where many things happen acoustically, I produce something that can be listened afterwards and related to that moment—but this includes the noise of wind on my microphone, the reverberation of rooms, the tapestry of tiny sounds that constitute the background, or the rumor of the sea waves or city.

Like anthropologist Tim Ingold remarked, we are actually not listening to sounds, but

we are listening in sound—a bit like we are not seeing light, we do see things in light. [2]

5 How did you decide to mix different materials (sounds, interviews, photos, words) to form a layered narrative?

My main intention was to collect sounds of Matsu and description of those sounds by some inhabitants. The recording process of course required me to move around and meet people. It was very natural for me to take notes on anecdotes and stories I encountered during the fieldwork. Photography is more ambiguous: I often need it as a way to document the places I visit, helping me remember the recording sites and situations, and even sometimes get some GPS coordinates of the locations. Also, I do enjoy producing images, using film or digital cameras, and in recent years, a large part of my professional work is to deal with sound mixing/design for cinema. In the year 2021, I started to play a bit more with the combination of photography and sound, assembling them into short films. I find the interweaving of those different materials very exciting not only as a creator but as a viewer: through a rather loose and modular montage, one can gather the meanings proposed by each sound, image and fragment of words and build relations among them. Even if the pace of the film isn't slow, the audience still have time to process the different elements during some listening moments.

Of course, I always have been under the influence and always wanted to make my own humble homage to the legendary film-maker Chris Marker, whose masterpieces *La Jetée*[3] and *Si j'avais quatre dromadaires*[4], built as a kind of slideshow, inspired me for this work, and ciné-ethnographer Jean Rouch whose earliest films are built with this fascinating discontinuity between sound and images.

6 This is not the first time you visited Matsu, nor is it the first time you created something about Matsu. How do you place this work among your other works related to Matsu?

By a very nice coincidence, I've been preparing two exhibitions at the same time. One was *When Islands Dream* that you curated for MOCA, Taipei, and *Listening to the Voices of the Islands* by Eric Chen and Liao Yi-Mei for the Matsu Biennial. For this last exhibition, physically set in Matsu, I did a first fieldwork in 2020, focusing on the sounds in the underground of abandoned or disused military underground bases. I spent a few days there recording resonances of the tunnels and room tones and assembled them with sparse texts and images. This led to a first creation based on surround sound entitled *An Island Far from the Sea*, which was shown during Taiwan International Documentary Film Festival 2021.

Then I prepared at the same time the short film *She heard nothing in Matsu.*

She heard everything and the exhibition for the Matsu Biennial. This last one is entirely devoid of images, texts and field recordings: *Stationary Waves* is a sound installation, very open to interpretation by visitors, with sound and found objects, which is directly related to a place, a construction in Fort #53 of Nangan island.

So, these two works are very much complementary. The film was made with fragments of mediated experiences, brought to the audience in Taiwan and abroad through audiovisual narration. Meanwhile, the exhibition could exist only in this specific architecture at Fort #53, and visitors entering the military building, using vision and audition, perceived the artwork inside an existing context as a physical experience.

 掃瞄 QR Code 觀看〈在馬祖，她一無所聞。她聽聞一切。〉
Scan the QR Code to watch *She heard nothing in Matsu. She heard everything.*

 掃瞄 QR Code 觀看〈一座遠離海洋的島嶼〉
Scan the QR Code to watch *An Island Far from the Sea*

1 "La pensée sauvage", Claude Levi-Strauss, Plon, France, 1962.
2 "Against Soundscape", Tim Ingold, in "Autumn Leaves: Sound and Environment in the Artistic Practice" by E.Carlyle (ed.), Double-Entendre, Paris, 2007
3 "La Jetée", Chris Marker, film, 28 min, 35mm, 1962
4 "Si j'avais quatre dromadaires", Chris Marker, film, 49 min, 35mm, 1966

Photo by Yannick Dauby

黃祥昀　Huang Hsiang-Yun

cloudartproduction.format.com

荷蘭萊頓大學媒體研究所碩士，研究聚焦於動態影像中的時間哲學、後殖民歷史方法論與網路藝術理論。文章散見於臺北數位藝術中心、今藝術、空總實驗波、國藝會現象書寫-視覺藝評：「雲的藝評」。從小熱愛當代藝術，近期嘗試將自己的詩集《一場雨的時間》轉化為實驗電影與行為藝術，經營平台「雲朵影像詩」，推廣以詩為劇本的影像創作。

Hsiang-Yun Huang (X.Y. Huang) is a visual artist and researcher of contemporary art theory based in Taiwan and the Netherlands.
She completed her bachelor in Philosophy at National Taiwan University, before going on to graduate at the Film and Photographic Studies master at Leiden University (NL) with the thesis "The Treatment of Time in Cinema: A Case Study of Cinema of Long Take, Tsai-Ming Liang's Stray Dogs (2013) and What Time Is It There? (2001)" employing a Deleuzian framework.

Photo by Huang Hsiang-Yun

〈記憶刺點：攝影與製圖工作坊〉，藝術家書 A4 尺寸，2021。
Memory Punctum : Photography & Cartography Workshop,, Artist Book, A4 size, 2021.

文｜黃祥昀

by Huang Hsiang-Yun

經過起霧的飛機、搖晃的渡船，我初次踏上馬祖。坐上機車後座的我，因為過於傾斜的坡度雙手冒汗，我們緩慢地、屏息地滑下去，只比走路的速度快一點；已經很黑的夜晚，順著另一個大坡，我們來到海邊。海邊的軌條砦與沿岸的瓊麻，構成尖刺的地景，劃破天空。

馬祖是一個帶刺的島，斜坡組成的地景是我回憶中焦慮害怕，有人追殺的惡夢場景變成現實。在傾斜的夢中，我想起很久很久以前，我曾經在一片黑暗中，撿起一顆帶有玻璃刀山的石頭，它在黑暗中，泛起微微的亮光，於是我選擇了它，雖然也有可能是它選擇了我。

一手握著石頭，一手沿著坑道的邊緣摸黑向前，觸感粗糙而潮濕，我慢慢向洞口走去。遠方傳來海風的聲音，既遙遠又親密、尖銳又綿密，好不容易漸漸適應了黑暗又來到了坑道底端的射口，頭頂是刺刀一般的消音錐，它們彷彿隨時會墜落、刺進腦門、掉回傾斜的夢中。最後，我隻身一人躺在被消音的、被遺棄的沙灘上，讓歷史的碎屑漂浮其中，海浪也逐漸鬆開防備的身體。

傾斜的、尖刺的、石礫的、粗糙的、墜落的，是我在馬祖的身體感。這個島從來沒有發生過陸面戰爭，地景卻充滿軍備元素。作為一個略知一二的「觀光客」和天生完全沒有方向感的「攝影師」，我在斜坡地景與尖刺海邊，只能不斷用令觀者迷路的「特寫鏡頭」去抓住這些刺感。特寫的質感就足以飽滿我的感知，而容不下任何其他的社會文化中的知識，知識賦予過多的重量和符號意義，而我的感知已經因為觸感的細節飽和了。因此，透過這本書，我想暫時把知識懸置一邊，轉而將身體與觸感體驗的馬祖地景呈現出來。[1]

工作坊設計理念

在踏查完馬祖後，我決定以「精神地理學」為起點，設計一套工作坊，讓旅居馬祖的人透過蒐集象徵地景的石頭、以觸覺和身體體驗坑道的質感，藉此回憶在自己意識流中的馬祖地景，製作一份融合感受、回憶與想像的「心理地圖」。

「心理地圖」的概念來自情境主義法國哲學家居伊·德波（Guy Debord）的想法，他認為地理環境會在有意識或無意識的情況下，使個人產生特定的情緒與行為，並提出了「心理地理學」這個研究旨趣。[2] 居伊·德波認為過度資本化的都市，使人以「異化的存在狀態」過生

活，為了要鬆動「既定都市空間—心理效應」這樣的鏈結並反抗商品化的空間配置，情境主義借用達達主義與超現實主義的「異軌」、「飄移」、「被建構的情境」這三種方法[3]，將空間重組、創造新的感受與想像。像是情境主義者會拿著倫敦的地圖在德國行走／迷路，又或者居伊·德波製作一個拼貼而成的地圖，名為《巴黎心理地理學指南》（Psychogeographical Guide to Paris，1957）在這個地圖上，「城市的呈現支離破碎，空白地區只有紅色箭頭指示。」[4] 這張地圖「有一種標記形式，它與其說是一種記錄，不如說是促使我們思考自己對於城市環境的感受程度。」[5]

我轉化了居伊·德波的概念，並加上「個人對地方的私密回憶」之元素，希望能夠讓參與者由自己的「身體感」出發製作「心理地圖」。平常我們使用的工具性用途的地圖，設計的目的常常是服務於統治者、城市規劃者、戰略軍事的，他們高高在上地鳥瞰島嶼上的區域配置，但從來沒有人問過，我們住的地方是怎麼規劃出來的？心理地圖則透過居民的視角，從地面上、從內心中去感受自己所居住的地景，探索自己對土地的情感與回憶。

記憶刺點：攝影與製圖工作坊流程

1 石頭地圖—透過動覺思考「地方／地景」，連結石頭與不同的身體姿勢。
2 盲人遊走—透過觸覺與聽覺引發感性回憶、刺點記憶。
3 心理地圖—介紹情境主義理論，將上述活動勾引出的感覺製作成拼貼地圖。

第一個活動是讓每個人先分享自己所撿的石頭背後的故事，接著大家圍一圈，輪流對石頭做不同的動作，不能跟別人重複。第二個是請每個人蒙眼睛，走入地下坑道，並在坑道中播放有關馬祖的聲音，例如海聲、摩特車的聲音、槍砲演練的聲音，參與者在坑道中透過觸覺與聽覺，觸發回憶與聯想。當大家恢復視覺後，將自己蒙眼睛探索坑道的感受寫下來，並加入所有這些活動的相關聯想。最後，參與者用石頭、感受字卡和混合我所拍的馬祖照片、積木（用來當作想像的地景）、毛線（用來當作馬祖的邊界或空間的邊界）當素材進行拼貼，製作屬於自己的心理地圖。

整體而言，參與者透過蒙眼走坑道，一方面是在字面意義上的失去方向感，進入未知的空間，另一方面用觸覺和聽覺等非視覺的方式體驗地景，激發自由聯想與回憶馬祖地景，最後這些素材成為參與者的拼貼材料，參與者將它們與自己所撿的石頭，重新拼成一幅心理地圖。在書本前半段，讀者所看到的「支詞片語」，是工作坊參與者在這三個活動中曾經說過的話語之重新拼貼，而這本書也讓讀者以「書」的方式體驗。

After foggy flights and rocking ferries, I set foot on Matsu for the first time. Sitting in the back seat of the scooter, my hands were sweating because of the steep slope. We slid down slowly and breathlessly, only a little faster than walking. In the dark night, along another big slope, we came to the seaside. The anti-landing piles by the sea and the sisal hemp along the coast form a thorny landscape that cuts through the sky.

Matsu is a thorny island, and the landscape of slopes makes my nightmares of anxiety, fear and being hunted down come true. In the slanted dream, I remembered that a long, long time ago, I once picked up a stone of the glass shards in the dark. It was in the dark with a faint light, so I chose it, although it may have chosen me.

Holding the stone in one hand, I walked along the edge of the tunnel in the dark with the other hand touching the rough and wet surface, and I slowly walked towards the entrance of the tunnel. The sound of the sea breeze came from afar. It was far away yet intimate, sharp yet smooth. After finally getting used to the darkness, I came to the battery fort at the bottom of the tunnel. On top of my head was a sound-absorbing cone like a bayonet. I fell back into the tilted dream. In the end, I lay alone on the silenced, abandoned sand, letting the detritus of history float in and the waves loosening their guard.

Sloping, thorny, gravel, rough, and falling are my physical sensations in Matsu. There has never been a war undertaken on the ground of the islands, but the landscape is full of military elements. As a "tourist" who knows a thing or two about Matsu and a "photographer" who has no sense of direction at all, I can only use the "close-up shots" that make viewers lose their way to capture the thorniness on the sloping landscape and the spiky seaside. The texture of the close-ups is enough to saturate my perception, leaving no space for other social and cultural knowledge to be accommodated. Knowledge gives too much weight and symbolic meaning, and my perception is already saturated with tactile details. Therefore, in this book, I want to temporarily suspend knowledge and instead present the Matsu landscape of physical and tactile experience.[1]

Design Concept of the Workshop

After exploring Matsu, I decided to use "psychogeography" as a starting point to design a workshop in which Matsu locals and people living in Matsu collect stones that symbolize landscapes, experience the texture of the tunnel with their tactile senses and bodies, and recall the Matsu landscape in their own streams of consciousness, creating a

"psychogeographic map" that integrates feelings, memories, and imagination.

The concept of "psychogeographic map" comes from the French Situationist philosopher Guy Debord, who believes that geography can produce specific emotions and behaviors for individuals, either consciously or unconsciously, and therefore proposed the approach of "psychogeography." [2] In order to loosen the link of "established urban space-psychological effect" and to resist the spatial configuration of commodification, Situationist borrows three methods from Dadaism and Surrealism, namely "détournement", "dérivé", and "constructed situations" to reorganize space and create new feelings and imaginations. [3] For example, Situationists would walk/get lost in Germany with a map of London, and Debord produced a collage map called *Psychogeographical Guide to Paris* (1957), in which "The city is shown as fragmented, joined by blank areas indicated only by the flow of red arrows." [4] This map "shows a form of notation that is significant less as a record than as a trigger for us to ponder our own sensitivities to the urban environment." [5]

I adapted Debord's concept and added the element of "personal and intimate memories of places" to allow participants to create a "psychogeographic map" from their own "sense of body". We usually use maps for instrumental purposes, and they are often designed to serve rulers, city planners, or military strategy. These maps have a bird's eye view of the regional configuration of an island from above, but no one ever asks how the places we live in are planned. Through the residents' perspectives, the psychogeographic map is a way to feel the landscape they live in from the ground and from the heart, and to explore their emotions and memories of the land.

Steps of Workshop

1 Stone Map: Through kinesthetic thinking of "place/landscape", participants draw connections between stones and their different body postures.
2 Blindfolded walking: To trigger perceptual memories and memory punctum of participants through touching and hearing
3 Psychogeographic map - Introducing the theory of Situationism, and to turn the senses evoked by the above activities into a collage map.

In the first activity, each participant shared the story behind the stone they had picked up, and then everyone gathered in a circle and took turns to make different actions on the stone. The second activity allowed each participant to walk blindfolded into an

underground tunnel where sounds of Matsu, such as the sound of the sea, motorcycles, and gunfire drills, were played. The participants were able to trigger memories and associations through their sense of touch and hearing in the tunnels. When they regained their vision, they wrote down what it was like to explore the tunnel while blindfolded and added connections to all the activities. Finally, in the third activity, participants used rocks, cards on which they wrote their feeling, photos I took of Matsu, blocks (used as imaginary landscapes), and wool (used as Matsu boundaries or spatial boundaries) as collage materials to create their own psychogeographic maps.

Overall, participants walk blindfolded into the tunnel, literally losing their sense of direction and entering an unknown space, while experiencing the landscape through non-visual means such as touch and hearing, stimulating free associations and memories of the Matsu landscape. In the final activity, these materials become collage materials for the participants, who reassemble them, along with the stones they have picked up, into a psychogeographic map. In the first half of the book, the "words" that the reader sees are a collage of the words that the workshop participants said during the three activities, allowing the reader to experience them in a "book".

1 這樣的作法是受羅蘭·巴特（Roland Barthes）的概念「知面」與「刺點」所啟發的。相較於一張攝影作品的「知面」意即照片背後相關的文化與社會知識，「刺點」則是觀者看到照片時，所觸發的個人的私密情感，它可能只是源自於照片中微不足道的細節，但卻因為觀者能連結到自身，而成為深刻的「刺點」。工作坊命名為「記憶刺點：攝影與製圖工作坊」，是將此概念與我在馬祖感受到的刺感形成一個「雙關語」，同時，也作為一種對學術研究中缺乏身體感的反抗，這即是說，我透過創作去挑戰與反省我自身的背景：哲學學術研究與當代藝術理論研究。

This approach is inspired by Roland Barthes' concept of "studium" and "punctum". Compared with the "studium" of a photographic work, which refers to the relevant cultural and social knowledge behind the photo, the "punctum" is the personal private emotion triggered when the viewer sees the photo. The insignificant details in the photos become profound "punctum" because the viewer can connect to himself. The workshop titled "Memory Punctum: Photography and Drawing Workshop" is a "pun" between this concept and the thorny feeling I felt in Matsu, and also as a resistance to the lack of physicality in academic research. That is to say, I challenge and reflect on my own background through art-making: philosophical academic research and contemporary art theoretical research.

2 Debord, G., 1955. Introduction to a Critique of Urban Geography, *Les Lèvres Nues #6*, Translated by Ken Knabb. Access Date: 2021.08.12. https://www.cddc.vt.edu/sionline/presitu/geography.html

3 Bishop, C., 2012. Artificial Hells : Participatory Art and the Politics of Spectatorship. Verso.

4 Ibid, p.85.

5 Ibid, p.85.

1982年出生於法國，定居、創作於巴黎與白朗峰霞慕尼。她以榮譽學位自法國國立高等美術學院畢業，並擁有藝術與美學博士，也於大學擔任資深講師。

自2000年，她於法國及世界各地發表作品，如巴黎龐畢度中心、東京宮、首爾總體美術館等）。她的作品被公共機構與私人典藏，如貝納德別墅基金會(Maison Bernard Endowment Fund)委託她於建築師安蒂洛瓦格建造的獨特建築中製作現地聲音裝置。2020年她榮獲法國文化部頒發的法國藝術與文學騎士勳章。2020年至2021年，她獲選為馬德里委拉斯開茲之家(Casa de Velázquez)的駐村藝術家。

《如果島嶼會作夢》是她在台灣的首次聯展。

Born in 1982 in France, Emma Dusong is based in Paris and Chamonix-Mont-Blanc. A graduate from the Superior National School of Fine Arts of Paris with honors of the jury, she is also a doctor in Sciences of Arts and Aesthetics and a University Senior lecturer.

Since the early 2000s, she has shown her work in France and abroad, such as Centre Pompidou Paris, Palais de Tokyo, Total Museum in Seoul. Her works are collected by public institutions as well as private collections such as the Maison Bernard endowment fund for which she made an *in situ* vocal piece for Antti Lovag's architecture. In 2020, she was appointed Knight of the Order of Arts and Letters by the French Ministry of Culture. She was in residency at Casa de Velázquez in Madrid in 2020-2021.

When Islands Dream is her first group show in Taiwan.

〈面向汝（Mĕing-hyong nȳ）〉，影像裝置，循環播放，與鄭嬌英、劉梅玉、劉宏文合作，2021。
Facing You (Mĕing-hyong nȳ), Video installation, loop, with Cheng Chiao-Ying, Liu Mei-Yu and Liu Hung-Wen, 2021.

文｜艾瑪‧杜松

by Emma Dusong

這是我在臺灣的第一個展覽，也是我首件與臺灣有關的作品。我在1990年代末開始成為藝術家，並自2004年起挑戰把歌唱放入我的作品中。我的主要媒介是人的聲音，以支持活生生的情感和感官體驗。我所有在移動裝置、錄像、印刷品、物件和表演中呈現的歌曲都是由我自己寫的。由於你可能不太認識我，在告訴你〈面向汝〉的製作過程前，我想向你介紹我最近三件具有代表性的歌唱作品：〈教室〉、〈Robines〉和〈Et O〉。

〈教室〉（Classroom，2012）是由發光的課桌椅組成的裝置。在一排排的課桌中，其中一張課桌邊動邊唱歌。起初，我一邊歌唱一邊用課桌玩一種手部遊戲：課桌檔板向上打開，在重新落下之前，我必須及時移開我的手。然後擴音器延長了我的動作，並在整場展示中讓這首歌逐漸成形。課桌唱道：「當我思考，當我思考」；檔板落下，「我的問題多於答案」；它落下，「但當我的答案多於問題」；它拍打桌子，「也許我會準備好去死……」甜美的聲音與檔板拍打桌子的聲響形成對比。這首作品肯定了

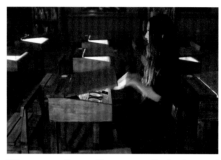

Classroom, Emma Dusong, motorized sound installation with singing trigger, illuminated school desks, one singing while moving, (lyrics, vocals and composition by Emma Dusong), 2012.

一種思維方式：如果沒有更多的問題，就沒有更多的生命。系統（由課桌檔板的鉸鏈代表）威脅著，而我們的手指可能會被抓住，阻止我們做我們一直在做的事情。課桌散發出的光暗示著人們試圖觸摸的知識。夜晚和夢境般的空間讓觀眾陷入遐想。然而，在盡可能自由學習的願望面前，課桌檔板的掉落也引起了疑惑和希望，這是一種明亮而模糊的體驗，我希望使觀眾陶醉，也同時喚醒他們。

〈Robines〉（2016）是在法國南部迪涅班（Dignes-les-Bains）的Robines地區拍攝的錄像裝置，其目的是讓消失的大海重獲新生。觀眾陷入一片寸草不生的黑色泥灰岩景觀中，眾多如幽靈般的聲音一個接一個地出現，就像水滴逐漸覆蓋地面。我尋找大海的聲音顏色，它的音調貫穿了一整個持續迴響的音符。很久以前，Robines的中心是海。今天，這

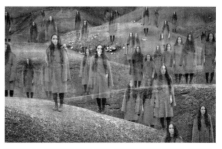

Robines, Emma Dusong, video projection, 2016.

裡的景觀已經變成了月球表面，像粗糙的波浪一樣起伏不定，轉瞬即逝的景觀在此遇上逐漸擴散而消逝的聲音。這個具有環境維度的作品，以大尺寸投射，往往最終會對來訪的觀眾產

生感官和催眠作用。〈Robines〉已經在法國國家現代藝術博物館、巴黎龐畢度中心展出，目前收藏於加桑迪（Gassendi）博物館。

Et O, (And O), Emma Dusong, video, (lyrics, vocals and composition by Emma Dusong), shot in Maison Bernard, architecture by Antti Lovag, 2017-2019.

〈Et O〉（2017～2019）受建築師安蒂洛瓦格（Antti Lovag）建築的啟發，以現場歌唱作品以及錄像的形式呈現。在位於法國南部濱海泰烏爾（Théoule-sur-Mer）的伯納德之家（Maison Bernard）展出的版本中，這間房子每天下午五點會唱歌。〈Et O〉概念形成的過程令我十分難忘，我在伯納德之家斷斷續續待了兩年，以便更瞭解它，觀察它的居民。這間房子用它的兩隻大手把我們攬入懷中，對我來說是如此有活力，以至於我挑戰為它創作一首歌。它似乎既強大又脆弱，房子本身和居民之間相互尋求保護。在我的歌裡，「我」和「你」交替出現，形成一段相互關係，並由「O」點綴。話語重複，或宣稱或暫停的聲音跨越了幾種情緒；整件作品基本上暗示了一種信任關係。這部作品稱為〈Et O〉；「Et（法文的「和」）代表在一起，而O代表歌曲中的標點符號，代表房屋結構中重複出現的形狀、唱歌的嘴的形狀和場景中的水（eau，法語中發音為o）。在這段從黎明拍攝到黃昏的錄像中，我在屋內徘徊唱歌的時間等於歌曲在屋內擴散的時間。〈Et O〉是一部非常積極的作品，但它也警告觀眾某種脆弱的一面。對我來說，譜寫這樣一部樂觀的作品去暗示信任關係是很難的，相比之下，我的作品中經常出現專制關係、虐待、阻礙，以及如何抵禦它。在這裡，話語權發生了轉變；我們不再把手拿開以避免被擋板砸到，我們也不再相互對抗而是在一起。我相信在這所房子的建造過程中，有這種在一起的想法，有一種溫暖的存在。毫無疑問，它是為了延伸不再存在的東西，並為想像它的家庭，也就是皮埃爾伯納德（Pierre Bernard）和他的三個孩子帶來溫度。這就是皮埃爾伯納德和安蒂洛瓦格的建築與我作品之間的聯繫——將生命注入到久遠的過去，讓生者重溫過去。

鑒於我以前的創作，當我被聯繫參加台北當代藝術館（MoCA）的《如果島嶼會作夢》展覽時，我覺得我作品的核心被理解了。我的藝術叩問自由和如何自由。唱歌成為了一種活著和面對逆境的工具。正如我們所看到的，我在這場展覽中的作品既與政治相關又如夢如幻。通過祈夢儀式的稜鏡來製作關於馬祖列島歷史的藝術作品，對我來說非常有意義。提問既是我作品的核心，也是祈夢儀式的核心，因此我對展覽主題有一種熟悉感，儘管我從未去過馬祖或臺灣。這種近在咫尺和遠在天邊的對比，貫穿了整件作品的製作過程。

由於新冠肺炎，我很快意識到我不能親自到馬祖列島，我必須在國外處理一切事務。起初

我不願意接受這件事，因為我喜歡和公眾一起表演，而不僅僅是在他們面前。通常我會把觀眾給我的能量唱回去，一起創造新的能量。我經常使用自己的聲音，但這次邀請，很明顯地必須要有馬祖的聲音參與。當我拍攝某人並記錄他的聲音時，我們在共用的空間內交換能量，建立信任並吸引第三人——觀眾，他們還沒有到場，但很快就會成為這個三方關係的一部分。我用來與所有參與方分享這一時刻的技術，受到了空間錨定的觸覺學啟發，即在一起的感覺和活著的感覺。我知道若從遠端拍攝這件作品，我便無法和表演者共享此一經驗，但我必須相信，透過指示和我們已建立的對話，創作過程將會水到渠成。

在這種情況下，我不可能將我的想法和作品建立在馬祖列島的地理空間裡，因為拍攝期間表演者和我從未處在同一空間。相反地，它必須是島嶼和我所處之地之間的空間。因此，距離本身就成為了空間，而這個空間作為投影的理想場域，也突然指向了作夢與提問。本質上而言，提問也是一種尋求傾聽的召喚。通過電話和電子郵件溝通的遠距關係，使這件作品更為豐富，這些交流也代表著距離本身。

這部作品的創作也涉及不同語言和方言之間的許多翻譯。我首先用英語寫了一封信，向馬祖居民介紹我的計畫和我以前的作品。我在信中寫道：「唱歌是一種抵抗行為；它允許我們表達還不能大聲說出來的東西」，並詢問他們在這個層面上有什麼問題。策展人謝宇婷將其翻譯成中文，並找到三位有興趣參與的馬祖居民：鄭嬌英、劉梅玉和劉宏文。我們很快就開始討論島嶼的過去、現在和未來，然後我用英文寫了歌詞，謝宇婷再譯成中文，讓劉宏文和黃開洋進一步把它翻譯成馬祖話。

因為這是我第一首多人合唱的聲樂作品，我決定用鋼琴譜曲，以便提供樂譜。這就是最後的翻譯——從馬祖話到音樂。我盡可能寫得簡單，讓非專業歌手也能唱出來。這首歌以重複的短語「Měing-hyong nỹ（面向汝）」開始，擊打地面，作為面對逆境時讓自己立足的一種方式。然後歌曲慢慢推進，用每個樂句來構建下一個樂句。旋律上升，朝向一個夢幻般的狀態，再回到地面，並在動詞「sei（是）」上以一個更高的音符結束。對我來說，無伴奏合唱同時顯示了一個人的力量和脆弱，因為聲音並不依賴於任何其他東西。它作為呼吸的延伸、生活的延伸而獨自升起。在拍攝過程中，我要求表演者閉上眼睛，夢著他們的問題。這本身就成為一種藝術表演——在一次分鏡中提出自己的問題、唱歌和作夢。因為技術團隊必須把影像逐一轉發給我看，所以拍攝過程花了比平時多一倍的時間。再加上臺灣和法國之間的時差，說實話，這對每個人都是挑戰。

在這個裝置中，歌者漂浮在床墊上，像石碑一樣升起，形成一組三聯畫。提問後，他們依序各自演唱無伴奏合唱，而另外兩個人的影像重新出現，顯示一首歌有能力呼喚其他人，

並創造集體能量。當他們睡覺時，我在法國地中海岸唱歌，回應來自馬祖海洋的聲音，讓來自馬祖列島的歌聲成為一種呼喚，迴盪在國外，而我們之間的空間是由海來計算的。馬祖居民被置於作品的中心，而作為一個外國人，我從遠處出現。

這件作品表明，我們可以通過夢想和質疑來面對我們的恐懼。任何人都可以自由探索馬祖列島的歷史，他們的過去、現在，以及可能的未來。作品中提出的問題有其脈絡，但從歌詞中我們便可以瞭解到，居民們面臨著一種威脅，而這種威脅可以投射到他們每個人的恐懼中。通過這件作品，我希望向觀眾提問：你如何面對你的恐懼和威脅？雖然沒有唯一的解決方案，但我的作品透過貼近我們的問題，以及與夢的距離，把我們每個人從恐懼和不動聲色中提升出來。

此外，床是我作品中反覆出現的一個元素。例如，在〈無題2〉（Untitled number 2，2008）中，我在床上與一種看不見的力量搏鬥，直到床破損。床這個空間本應具有支撐和固定的作用，最後卻倒塌了。在2013年，床由兩個會說話的枕頭暗示，描繪了已故親人的聲音，因為枕頭是承載記憶的物體，既柔軟又沉重。如此一來，床代表著一個危險和哀悼的地方。不過在〈面向汝〉中他們站起來了。

我不知道表演者各自提問和唱歌時在想什麼，但對我來說，他們表達了不同的情緒和觀點，從憤怒到詩意的嬉戲，再到擔憂。為了顯示他們的個性，每個人都有自己的分鏡，在某個時刻，在我的回聲中，在法國地中海岸的某個地方，我們聯合起來，一起唱歌：「面向汝（Měing-hyong nȳ）」。

製作〈面向汝〉是一個團隊的努力，所以我要感謝參與的每一個人。這件作品是第一步，肯定需要第二步──我必須製作另一件作品，而且這次是在去馬祖列島旅行之後。

所以，不久之後見！

This is my first exhibition in Taiwan, as well as my first piece related to Taiwan. I started off in the late 90s as an artist and since 2004 singing has been present in my work as a challenge. My main medium is the human voice to favor living, emotional and sensory experiences. All my vocal works presented in moving installations, videos, prints, objects, and performances are written by myself. Since you and I don't know each other, before telling you about the making process of *Měing-hyong nȳ (Facing you)*, I'd like to present to you three of my recent emblematic sung pieces: *Classroom*, *Robines*, and *Et O*.

Classroom (2012) is an installation of illuminated school desks. Among the rows of desks, one of them sings in motion. At first, I sing and play a hand game with the school desk. It opens up, and before the flap drops, I remove my hands just in time. The loudspeakers then prolong my action and continue to bring this song to life throughout the exhibition. The desk sings: "When I think, when I think"; the flap falls, "I have more questions than answers"; it falls, "But when I'll have more answers than questions"; slaps, "Maybe I'd be ready to die⋯" The sweetness of the voice contrasts with the flap slamming on the desk. The piece affirms a way of thinking: if there is no more question, there is no more life. The system (represented by the valve) threatens. Our fingers can be caught, which prevents us from doing what we have been doing. The light diffused by the desks suggests the knowledge that one tries to touch. The nocturnal and dreamlike dimension lulls visitors to reveries. However, in the face of the desire to learn as freely as possible, the fall of the desk flap also arouses doubts and hopes, a bright but ambiguous experience that I hope can enchant and awaken the visitors.

Robines (2016) is a video installation shot in the Robines in Dignes-les-Bains, in the South of France, as an attempt to bring the disappeared sea back to life. It plunges the audience into a stripped landscape of black marl where a multitude of vocal presences with a spectral dimension appear one after another, like drops of water gradually covering the ground. I looked for the color of the "voice" of the sea, with its intonation running through a continuous note. A long time ago, in the heart of the Robines, was the sea. Today this landscape has become lunar, undulating like rough waves. The ephemeral dimension of the landscape meets the evanescence of the voice, the latter of which disappears as it is diffused. This work with an environmental dimension, projected in large format, tends to become sensory and hypnotic for the visiting spectators. *Robines* has been exhibited in the National Museum of Modern Art, Centre Pompidou Paris, and is part of the collection of the Gassendi Museum.

Inspired by the architecture of Antti Lovag, *Et O* (2017-2019) is an *in situ* vocal piece as well as a video. In the version exhibited at Maison Bernard (Collection Fonds de dotation Maison Bernard, unique work) situated in Théoule-sur-Mer, South of France, the house sings every day at 5 p.m. The conception of *Et O* was a real adventure. I spent two years intermittently at Maison Bernard to get to know it better and observe its inhabitants. The house, which takes us in its two large arms, is so alive to me that I challenged myself to compose its song. The house appears to be simultaneously strong and fragile in a search of mutual protection between itself and its inhabitants. In my song, a reciprocal relationship alternates the *I* and the *you* punctuated by *Os*. The words are repeated, and

the voice—affirmed or suspended—crosses several emotions; the entire song essentially suggests a relationship of trust. The work is called *Et O*; *Et (And)* stands for being together, while *O* for the punctuating *Os* in the song, representing the recurring shapes of the house, the shape of a singing mouth, and for the water (*eau* is pronounced *o* in French). In this video, shot from dawn to dusk, the duration of my singing while wandering in the house equals that of the diffusion of the song across the house. *Et O* is a very positive work, but it also warns the audience of a certain vulnerability. It was hard for me to write such an optimistic work that suggests a relationship of trust. In contrast, what often comes up in my work are authoritarian relations, abuse, impediment, and how to defend oneself against it. Here, the discourse shifts; we no longer take our hands away to avoid being slammed, and we are no longer against one another but we are together. I believe that in the construction of this house, there was this idea of being together, of a warm presence, undoubtedly to extend what is no longer present, to bring tenderness to the family who imagined it, Pierre Bernard and his three children. And that is how the project of Pierre Bernard and Antti Lovag ties in with my work—it infuses life into the long gone for the living to relive the past.

Given my previous artworks, when I was contacted for the exhibition *When Islands Dream* for the Museum of Contemporary Art Taipei, I felt the core of my work understood. My art questions freedom and how to be free. Singing becomes a tool to be alive and to face adversity. As we've seen, my work is both politically engaged and dreamlike. Making an art piece on the history of the Matsu Islands through the prism of the Dreaming Ceremony made perfect sense to me. Questions are both central to my work and to the ceremony where the deity answers the dreamers' questions. Thus, I felt a sense of familiarity with the theme of the exhibition even though I had never been to the Matsu Islands or Taiwan. This contrast between proximity and distance continued throughout the process of making the piece.

Because of the pandemic, I soon realized I would not be able to come to the Matsu Islands in person, and that I would have to do everything from abroad. I was reluctant to accept this idea at first, for I like to perform with the public, not just in front of them. Usually, I would sing back the energy that the audience gives me, and together we would create new energy. I often use my own voice, but with this invitation, it was clear that voices from Matsu had to be involved. When I film someone and record their voice, we exchange energy within the space we share, building up trust and engaging a third person: the viewer, who isn't yet there but who will soon be part of this relationship— a three-way relationship. The technique I use to share this moment with all the parties

involved is inspired by haptonomy for an anchoring in space, the feeling of being together and of being alive. I knew that by shooting remotely, I wouldn't be able to share this experience with the performers, but I had to believe that through my instructions and our past conversations, this whole process would naturally occur.

Under the circumstance, I couldn't possibly build my idea and the piece in the geographical space of the Matsu Islands, nor any other space the performers and I never fully shared during filming. Instead, it had to be the space between the Islands and where I stayed. Distance in itself thus became *the space*. And this space, ideal for projections, suddenly took on meanings linked to the idea of dreams and questions. Essentially, a question is also a call seeking listening. The piece is enriched by its long-distance relationship through calls and emails, exchanges implying remoteness.

The creation of this piece also involved much translation among different languages and dialects. I first wrote a letter in English to introduce my project and my previous works to the inhabitants of Matsu. In the mail, I wrote: "Singing is an act of resistance; it allows us to express what cannot be said out loud yet," and asked what their questions were in that dimension. The curator, Yu-Ting Hsieh, translated it into Mandarin and found three Matsu residents who were interested in participating: Cheng Chiao-Ying, Liu Mei-Yu and Liu Hung-Wen. We soon started conversations about the islands, their past and present, and their perspectives on the future of Matsu. I, then, wrote the lyrics of the song in English. Yu-Ting Hsieh translated it into Mandarin and Liu Hung-Wen and Huang Kai-Yang to further translated it into the Matsu dialect.

Because it was my first plural vocal piece, I decided to compose the song with the piano so that I could send notes for everyone to follow. This was the final translation: from Matsu language to music. I made it as easy as I could for non-professional singers to sing it. It begins with the repeated *Měing-hyong nỹ (Facing you)*, hitting the ground as a way to ground oneself in the face of adversity. Then the song progresses slowly, using each musical phrase to build the next one. The melody rises, toward a dreamlike state to return to a rooted place to end on a higher note on the verb *sei*, (be). To me, singing a cappella simultaneously shows one's strength and vulnerability, as the voice doesn't rest on anything else. It rises alone as an extension of breathing, an extension of living. During the shooting, I asked the performers to close their eyes and dream about their questions. It became an art performance in itself to ask one's question, to sing, and to dream in a single sequence. Because the technical crew had to send me the videos take by take to watch, the shooting process took double the time it usually requires. That plus the time

difference between Taiwan and France, it was honestly quite a challenge for everyone.

In the installation, the singers float on mattresses and rise like monoliths, to form a triptych. After asking their questions, they sing a cappella, one at a time, while the other two reappear showing how a song has the power to call out others and create collective energy. While they sleep, I sing on the French side of the Mediterranean Sea, responding to the voices coming from the Matsu Sea. The song from the Matsu Islands becomes a call that echoes abroad. And the space between us is figured by the sea. The inhabitants of Matsu are placed at the center of the piece and, as a foreigner, I appear from a distance.

This piece suggests that we can face our fears by dreaming and questioning. Anyone is free to explore the history of the Matsu Islands, their past, their present, and their possible future. The questions asked in the piece are quite contextual, but from the lyrics, we can learn that the inhabitants are facing a threat, and this threat remains open to projections of each of their own fears. With this piece, I hope to raise questions to the viewers: how do you face your fear? And threats? While there isn't only one solution, my piece is here with the intention to lift every one of us from fear and immobility through proximity with our questions, and through distance with our dreams.

On a side note, beds are a recurring element in my work. In *Untitled number 2* (2008), for example, I fight on a bed with an unseen force until the bed breaks. This place, the bed, which is meant to support and secure, finally collapses. In 2013, a bed is suggested by two talking pillows describing the voice of a deceased loved one; here the pillows hold memories, soft and heavy. So far, beds have been a place of danger and mourning, but in *Mĕing-hyong nȳ*, the beds now stand up.

I don't know what went through the performer's minds when they each said their questions and sang, but to me, they expressed different emotions and perspectives going from anger to poetic playfullness passing by worry. To show their individuality, they each have their own sequence and at some point, in my echo, somewhere on the French side of the Mediterranean Sea, we unite and sing together: *Mĕing-hyong nȳ (Facing you)*.

Making *Mĕing-hyong nȳ (Facing you)*, was a team effort, so I would like to thank everyone involved. This piece is also a first step that definitely requires a second: I will have to make another piece, but this time after a trip to the Matsu Islands.
So, see you there soon!

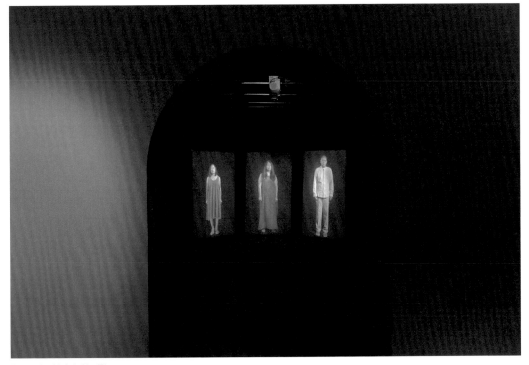

Photo by Hsieh Yu-Ting

1872　東莒島燈塔興建
The Construction of Dongju Lighthouse began.

1949　第74軍轉進馬祖
The 74th army arrived in Matsu.

1956　馬祖實施戰地政務
Military Administration was implemented in Matsu.

1958　八二三砲戰之後，中共開始實施「單打雙不打」炮擊金馬地區的
軍事行動
After the Second Taiwan Strait Crisis, China started to implement the
intermittently shelling of the Kinmen-Matsu region on odd days.

1960　陸軍反共救國軍指揮部成立於東引
The Anti-Communist National Salvation Army was established.

1965　陸軍馬祖防衛司令部成立
The Matsu Defense Command was established.

1969　梅石電影院遭受炮擊，多人傷亡
The bomb attack at Meishi Movie Theater caused multiple
injuries and deaths.

1979　中美建交，中共宣布停止單日砲擊金馬地區的軍事行動
China and the United States became allies, and China announced ceasing
the military action of bombing on odd days in Kinmen-Matsu region.

1990

馬祖第一屆民選代議士

The first parliamentarians were elected in Matsu.

1992

馬祖解除戒嚴

The Military Administration in Matsu was lifted.

1993

馬祖第一次民選縣長

The first Chief of County was elected in Matsu.

1999

馬祖開放小三通

The Mini Three Links between Huangqi and Mastu was introduced.

2012

馬祖舉辦博弈公投

A referendum on the gambling industry was held.

2015

擺暝通過國家重要民俗

"Baiming" was officially registered as an important national cultural customs.

2019

《國家語言發展法》通過後，馬祖閩東語作為中華民國
本土語言之一，受到法律保護

After the *Development of National Languages Act* was passed,
the Eastern Min language started to be legally protected and recognized
as one the country's local languages.

2022

連江縣把馬祖閩東語列為縣內學生的必修課

Lienchiang County implemented mandatory courses for the Eastern
Min language for students in Matsu.

《如果島嶼會作夢》

主編　謝宇婷
編輯協力　李宛儒
專文撰稿　謝宇婷、龔卓軍、陳平浩、田偲妤、林意真
　　　　　許生翰、王煜松、澎葉生、黃祥昀、艾瑪・杜松
翻譯　謝宇婷
審校　江鈺婷、王一中
專書設計　TODAY STUDIO
印刷　九水有限公司
初版　2022年6月
國際標準書號　978-626-96157-0-4
發行數量　300本
定價　600元

出版社　自牧文化事業有限公司
　　　　地址：106 台北市大安區信義路四段296號15樓
　　　　電話：02-27208407　網站：zimu-culture.com
　　　　E-mail：zimu.contact@gmail.com
總經銷　紅螞蟻圖書有限公司
　　　　地址：114 台北市內湖區舊宗路2段121巷19號
　　　　電話：02-27953656　傳真：02-27954100
　　　　E-mail：red0511@ms51.hinet.net

指導單位　連江縣政府
承辦單位　連江縣政府文化處
本出版品獲連江縣政府2022年出版補助

When Islands Dream

Chief Editor　Hsieh Yu-Ting
Assistant Editor　Li Wan-Ju
Author　Hsieh Yu-Ting, Gong Jow-Jiun, Chen Ping-Hao, Sally
　　　　Tian, Alexandra Lin, Sean Trudi Hsu, Wang Yu-Song,
　　　　Yannick Dauby, Huang Hsiang-Yun, Emma Dusong
Translator　Hsieh Yu-Ting
Proofreader　Tammy Yu-Ting Chiang, Stephen Wang
Book Design　TODAY STUDIO
Printer　Jiu-Sui Print Co., Ltd
First Edition　Jun, 2022
ISBN　978-626-96157-0-4
Copies Printed　300
Price　NTD 600

Publisher　Zimu Culture
　　　　Address: 15F., No. 296, Sec. 4, Xinyi Rd., Da'an Dist.,
　　　　Taipei City 106 , Taiwan (R.O.C.)
　　　　Tel: 02-27208407　Website: zimu-culture.com
　　　　E-mail: zimu.contact@gmail.com
Distributer　Red Ants Books Co., Ltd
　　　　Address: No. 19, Ln. 121, Sec. 2, Jiuzong Rd., Neihu
　　　　Dist., Taipei City 114066, Taiwan(R.O.C.)
　　　　Tel: 02-27953656　Fax:02-27954100
　　　　E-mail: red0511@ms51.hinet.net

Supervisor　Lienchiang County Government
Organizer　Lienchiang County Government Cultural Affairs
　　　　Department
This book received a 2022 Publishing Grant from the Lienchiang
County Government.

國家圖書館出版品預行編目（CIP）資料
如果島嶼會作夢＝When islands dream／謝宇婷、龔卓軍、陳平浩、田偲妤、林意真、許生翰、王煜松、澎葉生、黃祥昀、艾瑪・杜松專文撰稿；
謝宇婷主編 .-- 初版 . -- 臺北市：自牧文化事業有限公司，2022.06　112面；18×24.5公分　ISBN 978-626-96157-0-4（精裝）
1.CST：藝術 2.CST：作品集 3.CST：文集
902.33　　　　　　　　　　　　　　　　　　　　　　　　　　111007547